Idea Colliders

metaLABprojects

The metaLABprojects series invites readers to take part in reimagining print-based scholarship for the digital age. It provides a platform for emerging currents of experimental scholarship, documenting key moments in the history of networked culture, and promoting critical thinking about the future of cultural institutions. www.metalab.harvard.edu.

Series Editor
Jeffrey T. Schnapp

Idea Colliders

The Future of Science Museums

Michael John Gorman

The MIT Press
Cambridge, Massachusetts
London, England

© 2020 Massachusetts Institute of Technology

All rights reserved. No part of this book may be reproduced in any form by any electronic or mechanical means (including photocopying, recording, or information storage and retrieval) without permission in writing from the publisher.

This book was set in Minion Pro by the MIT Press. Printed and bound in the United States of America.

Library of Congress Cataloging-in-Publication Data

Names: Gorman, Michael John, author.
Title: Idea colliders : the future of science museums / Michael John Gorman.
Description: Cambridge, Massachusetts : The MIT Press, [2020] | Series: MetaLABprojects | Includes bibliographical references.
Identifiers: LCCN 2019050148 | ISBN 9780262539241 (paperback)
Subjects: LCSH: Science museums.
Classification: LCC Q105.A1 .G67 2020 | DDC 507.4--dc23
LC record available at https://lccn.loc.gov/2019050148

10 9 8 7 6 5 4 3 2 1

For Lenka

Contents

Acknowledgments ix

1 The Edge Effect 1

2 Three Tales from the Future 23

3 Rise of the Hybrids 41

4 Safe Sex in the Academic Realm: The Science Gallery Experiment 69

Windows: Ten Shifts: Redefining Cultural Institutions 103

5 The Biological Turn 117

6 Piercing the Filter Bubble: Science Museums and Social Capital 131

7 From Incubators to Idea Colliders 149

Notes 155

Acknowledgments

A great many people have inspired and informed this book through creative and critical conversations and provided support and encouragement on the journey. While this is very much my personal perspective, it is a perspective on a collective enterprise involving the privilege to collide with and learn from a great number of artists, scientists, designers, curators, cultural entrepreneurs, rule-breakers, and creative thinkers around the world.

For their important involvement in shaping Science Gallery Dublin, I would like to acknowledge John Hegarty, Mike Coey, Chris Horn, Deirdre Tracey, Diarmuid O'Brien, Chris de Burgh, John Climax, Colm Long, David Martin, Shay Garvey, and all the Science Gallery Dublin team, board, and supporters over the years. For being part of the founding team of Science Gallery Dublin and for the shared journey of experimentation, I especially thank my unstoppable partners in crime Lynn Scarff and Lea O'Flannagain.

For their important role in kicking off the creation of Science Gallery International, in addition to those already mentioned, I thank Fergal Naughton, Clare Matterson, Peter Barron, and the team at Google.org.

As key early team members of Science Gallery International, true to the IDEALS (Iterate, Deliver, Enable, Ambition, Love, and Support), I thank especially Sarah Durcan, Fionn Kidney, Katrina Enros, Danny Browne, and Louise O'Reilly. For taking on the torch of Science Gallery International after my departure for Munich and leading the global network to the next level, I take my hat off to

Andrea Bandelli and his great team at Science Gallery International. For championing a new vision of the globally networked university through innovation in public engagement, and for embracing the Science Gallery vision, I thank Paddy Prendergast.

For being such wonderful companions, supporters, and "critical friends" along this unfolding and unfinished journey, I especially thank Ken Arnold, Paola Antonelli, Oron Catts, Tony Dunne, Fiona Raby, and David Edwards. For their roles in creating Science Gallery London and often challenging and always stimulating discussions: Simon Howell, Rick Trainor, Deborah Bull, Daniel Glaser, Tim Henbrey, and the whole Science Gallery London team and supporters. For their instigation of the development of Science Gallery Bengaluru and energizing conversations: Kalpana and Pradeep Kar, K. Vijay Raghavan, Mukund Thattai, Kiran Mazumdar Shaw, I.S.N. Prasad, Yashas Shetty, Geetha Narayanan, and Jahnavi Phalkey. For instigating and leading Science Gallery Melbourne with vision and ambition: Glyn Davis, Jacyl Shaw, Karen Day, Julie Wells, and Rose Hiscock. For the birthing of Science Gallery Venice: Michele Bugliesi, Marco Sgarbi, Silvia Casini, Fabio Poles, Francesco Zirpoli, and the Science Gallery Venice team. For inspiring me in relation to thinking differently about brand and design and for shaping the Science Gallery identity, I thank Ciaran O'Gaora and his team at ZeroG and Ralph Ardill. For developing the Science Gallery brand further and making the materials produced by Science Gallery look so amazing, I especially thank Brian Nolan and the team at Detail. For the opportunity to learn in the company of a wonderful cohort of peers, I am also grateful to the Chief Executive Programme of National Arts Strategies and the instructors at Harvard Business School and the Ross School of Business.

I thank the Wellcome Trust, the Naughton family, and Ron and Barbara Cordover for their generous support and encouragement

over the years, and Trinity College Dublin for supporting and providing a space for experimentation that occasionally went outside its comfort zone.

For having the courage and vision to initiate Biotopia in Munich, and for luring me away from Science Gallery, I thank Auguste von Bayern, Benedikt Grothe, and Ferdinand zur Lippe.

For ongoing creative collisions and constant inspiration through their deeds and conversations, I thank (in alphabetical order): Alison Abbott, Stan Altman, Dennis Bartels, Ralph Borland, Ian Brunswick, Linda Conlon, Steffi Czerny, Emily Dawson, Loughlin Deegan, Zack Denfeld, Robert Devcic, Persi Diaconis, Evelina Domnitch, Linda Doyle, John Durant, Joshua Foer, Eric Fraad, Peter Galison, Maribel Garcia, Dmitry Gelfand, Daisy Ginsberg, Hans Gubbels, Honor Harger, David Harvey, Jens Hauser, John Herlihy, Chevy Humphrey, Eric Jacquemyn, Natalie Jeremijenko, John S. Johnson, Martin Kemp, Anthony King, Ariane Koek, Cathrine Kramer, Bruno Latour, Chris Leonard, T. M. Lim, Christopher Lindinger, Gail Lord, George Loudon, Aoife McLysaght, Chico McMurtrie, Arthur Miller, Tengku Nasariah, Ann Neumann, Cliona O'Farrelly, Jane Ohlmeyer, Luke O'Neill, Neri Oxman, Josep Perello, Jonah Peretti, John Pethica, Mike Petrich, Clare Pillsbury, Patricia Quinn, Christian Rauch, Marie Redmond, Douglas Repetto, Jonathan Rose, Mark Rosin, Jeffrey Rudolph, Simon Schaffer, Brian Schwartz, Rob Semper, Eric Siegel, Nina Simon, Silvia Singer, Sissel Tolaas, Johannes Vogel, Margaret Wertheim, Willie White, and Karen Wilkinson.

And for love, support, and distraction, I thank my family: Lenka, Maia, Thaddeus, and Benjamin; my parents, Michael and Marianne Gorman; and my super siblings, Sophie and Daniel Gorman.

1
The Edge Effect

> Let's take my favourite example of creativity from science. In ecology, where two ecosystems meet, such as the forest and the savannah, the point of intersection is the site of "edge effect." In that transition zone, because of the influence the two ecological communities have on each other, you find the greatest diversity of life, as well as the greatest number of new life forms.[1]
> —Yo-Yo Ma, cellist and "venture culturalist"

This book is about what Yo-Yo Ma describes so beautifully as the "edge effect," when applied to creating spaces to nurture the cross-pollination of ideas. It is about the challenge of creating new kinds of cultural environments that facilitate the collision of ideas from different areas—science, art, design, technology—and the emergence of new critical conversations and new creative approaches—new "life forms."

It explores where our current raft of science museums and science centers have come from, and asks how we might reconfigure and pierce the protective exoskeletons of our traditional cultural and scientific institutions to permit the emergence of fertile "edge spaces," bringing together people from diverse backgrounds and perspectives around shared interests and concerns.

Let me begin with a story. Back in 2009, an exhibition and festival called *Infectious* opened its doors at Science Gallery, a recently established gallery space built on a former car park at the edge of the campus of Trinity College in the center of Dublin, Ireland, dedicated to fostering "creative collisions between science and art" and focusing on a young adult audience aged 15 to 25.

With a banner on the gallery glass façade inscribed with the large ominous words "INFECTIOUS: STAY AWAY" and adorned with biohazard signs, there was significant cause for concern when, just a few days after the opening, the Mexican swine flu pandemic broke out, even causing some local citizens to alert the

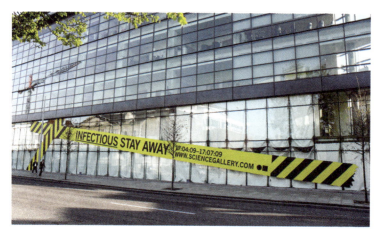

Facade of Science Gallery Dublin during the *Infectious* exhibition, 2011. *Source:* © Science Gallery, Trinity College Dublin.

Dublin City Council that Trinity College had been infected. The gallery responded by hosting a rapid response discussion about the pandemic, inviting influenza experts and epidemiologists to discuss with the public and the media what was going on as the (ultimately rather underwhelming) pandemic unfolded.

A review of *Infectious* in the US journal *Science* noted that "even a pandemic can have a silver lining. A flood of visitors to an Irish exhibition about epidemics has become a mother lode of data on the spread of disease."[2]

Visitors that ignored the signs and dared to enter *Infectious* were provided with RFID tags on lanyards, allowing them to "infect" each other electronically during their visit, creating a digital epidemic in the gallery, which was part of a research experiment on physical "small world" networks being run by a research institute in Turin.

On entering, visitors were also invited to kiss a Petri dish containing horse blood agar, in a project by artist Maria Phelan.

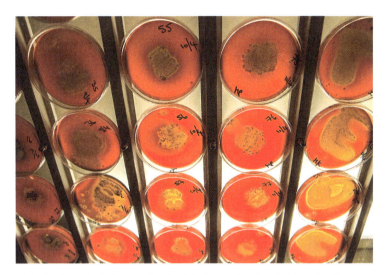

Maria Phelan, *Kiss Culture*, part of the *Infectious* exhibition at Science Gallery. Visitors were invited to kiss a Petri dish containing horse blood agar, which was then incubated overnight, allowing their bacterial flora to be displayed on the walls of the gallery. *Source:* © Science Gallery, Trinity College Dublin.

Their kisses were incubated, and two days later they were invited to come back to the gallery to inspect their personal bacterial flora, on view to all on the gallery wall.

During the opening weekend, members of the public participated in a viral flash mob challenge concocted by Jonah Peretti and comedian Ze Frank, who were right at that moment in the process of launching a new media company called BuzzFeed.

Unbeknownst to the curators, one of the artists involved in *Infectious*, Anna Dumitriu, secretly stole a sample of anthrax from the gallery, and photographed it at different public locations around Dublin, causing a panic of the gallery staff until

Following the *Infectious* exhibition, which was attended by over 45,000 people in three months, the journal *Nature Immunology* published (in a first for the journal) a dialogue about art and the immune system between Luke O'Neill and one of the participating artists.[3]

A research experiment carried out during the exhibition analyzed the DNA of visitors for presence of an overactive MAL protein, indicating increased risk for malaria, constituting the largest ever experiment on this gene conducted on the Irish population.

The RFID experiment prototyped by the Italian researchers in *Infectious* led to mapping of infection pathways in a number of Italian children's hospitals, allowing for new preventative measures to be implemented.[4]

Infectious, anticipating the age of COVID-19, was at times unpredictable, nerve-wracking, and even chaotic, but it embodied many aspects of an approach that has since then become identified with Science Gallery, and a growing family of new transdisciplinary cultural institutions that are involved in colliding science, art, design, and technology to create new forms of experience.

To explain this ever-evolving approach, let me describe how *Infectious* came about.

At one of the regular meetings of the so-called "Leonardo Group"—a changing group of up to fifty creative individuals drawn from science, art, design, technology, and media volunteering their time to help shape Science Gallery activities—two Trinity College immunologists, Luke O'Neill and Cliona O'Farrelly, suggested that we should create a new Science Gallery exhibition on the theme of "Plague." At the time, the gallery team was not completely convinced—"plague" sounded rather negative and conjured up "Bring out your dead!" images from Monty Python's film *The Holy Grail*.

On discussing further with others, the title *Infectious* was chosen, opening up the possibility of exploring contagion in all its forms, from jokes and religion to financial panic and viral marketing, in addition to epidemics.[5]

A transdisciplinary curatorial team was selected, which included not only immunologists, but also an economist and expert on bank runs, Patrick Honohan, who shortly afterwards became governor of Ireland's Central Bank during a time of major financial crisis, as well as contagious media expert and Huffington Post cofounder Jonah Peretti.

An open call for ideas was developed and spread by the different curators and advisors through their communities, leading to a huge number of diverse proposals for artistic installations, scientific experiments, creative workshops, and events.

This process of orchestrated yet serendipitous collisions of ideas is schematized in the diagram on the following page.

On the left-hand side of the diagram, we see the community engaged with the Science Gallery, at different levels of commitment. First we have the Visitors, who may first wander into the gallery looking for a coffee without initially looking for a cultural experience, but will be drawn through gallery exhibits even as they seek caffeine. Visitors (and the media, who are often intrigued by dynamic new exhibitions connected to societal concerns) provide public exposure to the projects on display in the gallery and in some circumstances can provide either formal (for example, through a public research experiment, gathering data from visitors) or informal (for example, through discussions with mediators) feedback that could influence future development. Visitors who are interested in developing a relationship with the gallery can sign up to become Members. In addition to learning about events and new exhibitions, Members begin receiving open calls for ideas from the gallery. A small percentage may then become Participants—the

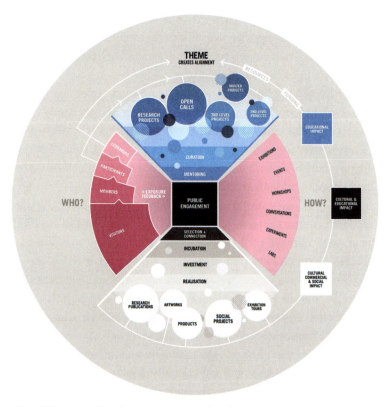

Idea Collider graphic schema of Science Gallery development process, designed by Detail.Design Studio. *Source:* © Science Gallery, Trinity College Dublin.

creators (artists, scientists, designers, engineers) who present their projects on the floor of the gallery. And then some Participants may be invited to join the Leonardo Group, a frequently changing group of up to fifty "inspirational" creative people who help shape the gallery vision and chart key themes and concerns for the gallery to explore. The community should be understood as rotating rapidly.

At the top of the Idea Collider, we have the themes. The strongest themes—such as *Infectious*—are those which naturally bring together strange bedfellows (practitioners from very different realms) and which connect strongly with current public "matters of concern." They should address big societal issues, allowing for different perspectives and approaches, but not be overly broad so as to lose focus. They should ideally touch a nerve.

Around a theme, a small transdisciplinary curatorial team is formed, often including people who have never curated anything in their lives—scientists, artists, economists, engineers, designers, architects, writers, humanities scholars. In addition to selecting the projects, these people have a critical role to reach into their different communities and help propagate the open call for ideas into areas which the gallery would never otherwise reach.

Of the hundreds of proposals usually generated, a fraction are then selected. These could include artistic installations, public research experiments, student projects. These are then filtered down and provided with financial and curatorial support to manifest as installations, events, experiments, or workshops on the floor of the gallery.

At this moment, there is an opportunity for various kinds of feedback from the public on the creative project, allowing for prototyping in public, and triggering conversations about the future.

Playing a crucial role in this interplay between the visitors and the creative projects are the Mediators—normally students from the university who are not tour guides or didactic "explainers" but

who instead engage in multi-faceted conversations with the visitors to tease out the issues around the projects on exhibit. Often these conversations are triggered by an object on display, but become conversations about ethics, the future, and what kind of society we want to live in.

Importantly, public engagement is not considered the end point but the mid-point of this process, with many projects generated going on to have some form of afterlife, relating to the bottom part of the funnel, and usually happening through involvement of other external partners. This could include scientific experiments leading to publications in peer-reviewed journals, artistic commissions going on to be shown elsewhere, and in some cases new social/cultural and educational projects or even commercial products emerging—for example, SureWash, a new and ever more relevant hand-washing technology created by a Trinity College engineering researcher, that was first trialed with the public at *Infectious*.[6]

An important side benefit of such a process is that it produces surprises, ensuring a constant stream of unexpected proposals and approaches. For example, when Science Gallery issued an open call for projects in relation to human enhancement for the show *HUMAN+*, nobody expected to see a fully calculated proposal for a "euthanasia rollercoaster," designed for a future society of extreme longevity, where people might seek a way to pass out of this world in a state of euphoria on a darker type of fairground attraction.

While it has some features specific to the Science Gallery context, the Idea Collider described here is very much inspired by other cultural labs that adopt similar approaches, in particular David Edwards's Le Laboratoire, originally established in Paris in 2007 and subsequently based in Cambridge, Massachusetts. It is also a highly schematized version of a reality that is inevitably far messier.[7]

An important aspect of the Idea Collider is that impact and value are delivered at every stage in the process, helping to make it

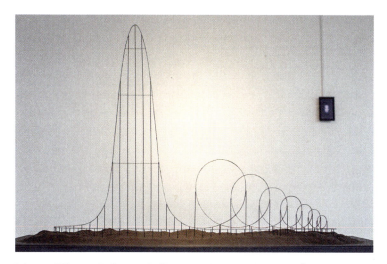

Julijonas Urbonas, Euthanasia Rollercoaster. *Source:* © Science Gallery, Trinity College Dublin.

a low-risk exploratory process from the perspectives of the creators (participants) and supporting institutions. For university and school courses developing projects according to the themes, educational impact is delivered even if the projects often don't continue to further development. For the gallery, cultural and educational impact are delivered, helping the gallery to fulfill its mission as a cultural institution, even if the project does not go on to have an "afterlife." And for the small percentage of projects that go on with other partners and receive further investment or support, further commercial, social, and cultural value are delivered to new external audiences. Generally these happen independently of Science Gallery, with the exception of international tours of exhibitions and installations, which, in addition to multiplying opportunities for exposure and feedback, generate a modest revenue stream to offset the initial costs of the process.

Benefits of this approach are that the gallery is assured of a constant stream of new ideas and approaches coming from the outside, rather than depending on the ideas of its internal team, and its role becomes more like that of a broker, host, and creative platform than that of a broadcasting "content provider." A consequence of this approach is that one must abandon the idea of a linear narrative, and rather embrace approaching a current concern from a multiplicity of perspectives and approaches. People who approach a Science Gallery exhibition wanting to be taken through a topic in a structured, methodical way and to leave with a command of all the facts will generally be disappointed. The exhibitions are more like tapas than a multi-course menu, where some elements will connect more than others with visitors, and the conversation with the mediators plays a critical role, offering "depth on demand" based on visitors' interests, but ideally not overpowering visitors with information that may make them glaze over. Events built around the exhibition themes focus on offering opportunities for informal contact with the scientists and artists behind the content. Whereas most science centers are quite removed from the world of current scientific research and, at the other extreme, some more traditional science museums require scientists to vet and approve all content, Science Gallery draws scientists into conversational contact with artists, designers, policymakers, and the public, and brings their work to the public in a context that is not framed by the science itself but by societal concerns. The social model of Science Gallery was designed with a core target demographic in mind—15- to 25-year-olds, young adults.

This book is not a bid for the universalization of the Science Gallery model, but an appeal for experimentation in public engagement, where, for example, radically different models might turn out to work better with the core audiences of 6–12 year olds, dragged along by relatives and teachers to science centers

and museums. Nonetheless, the point remains that adult and young adult audiences have been woefully underserved by the "infantilization" of science centers, and that Science Gallery is one alternative approach that can connect with these audiences.

Science Gallery, currently developing as a global university-linked network in cities including London, Melbourne, Bangalore, Detroit, Venice, Rotterdam, and Atlanta, is just one example of a family of new experimental spaces that are coming into existence. Over the past decade, a raft of such experimental transdisciplinary and future-oriented centers have emerged, building on the pioneering work of organizations such as The Exploratorium in San Francisco, Ars Electronica in Linz, ZKM in Karlsruhe, CCCB in Barcelona, and SymbioticA, the biological lab for artists in the University of Western Australia. These new centers include, in addition to Le Laboratoire, the Ars Electronica Center in Linz, Wellcome Collection in London, ArtScience Museum in Singapore, UCLA Art Science Lab, and CAST at MIT. Many more are now emerging, including Futurium in Berlin, Biotopia in Munich, and the Museum of the Future in Dubai.

We are also seeing transformations in more established institutions, for example, the visionary design exhibitions and research projects led by Paola Antonelli at MoMA and the exemplary reinvention of the once rather stuffy V&A in London into a cultural dynamo under the leadership of the late Martin Roth. We also have a raft of new projects that seek to stimulate new perspectives on museums and related settings, from Museum Hack providing irreverent tours of famous museums, to Joshua Foer's Atlas Obscura, to Nina Simon's OF/BY/FOR ALL project to make museums more relevant to their local communities. It is an exciting time to found a new transdisciplinary, future-oriented cultural institution, and also to create a space for experiment, an "edge space" at the fringes of an established, perhaps more traditional institution—museum, university, library, arts center.[8]

Nonetheless, there are many established cultural institutions that remain hooked on the idea that improvement requires a shiny new building by a "starchitect"—new hardware for cultural transmission, rather than a (potentially much less costly) new underlying operating system. One could even ask, in view of the myriad opportunities to connect people and ideas through our multiple prosthetic digital devices, do we really need physical buildings at all, to serve as idea colliders or places to explore possible futures? Especially in an age of global pandemics, could we not do all of this stuff online?

Perhaps the most vivid demonstration that this is for the moment not the case and that, in spite of the hopes of the early pioneers of virtual worlds (remember Second Life?), we are condemned to inhabit our biological bodies, is the colossal investment of the largest digital companies—Google, Apple, Facebook—in their billion-dollar utopian physical campuses—for example, the projects by Bjarke Ingels Group and Thomas Heatherwick for Google's "groundscraper" campus in London and its tented Mountain View headquarters, or Apple's new "spaceship" Cupertino campus designed by Foster and Partners. In the case of Apple, the opportunity for "connection and collaboration between employees" is the main stated goal; for Google, the designs seek to maximize "casual collisions of the workforce" with no employee being more than a 2.5-minute walk from any other, although a more cynical view is that these palaces, replete with hanging gardens, cornucopian kitchens, gyms, and swimming pools are intended as gilded cages from which employees will never want to return home.[9]

What can we learn from the extravagant efforts made by the world's largest technology companies to stimulate spontaneous collisions amongst their employees, as we seek to design new kinds of cultural institutions? Perhaps that we should place serendipitous, embodied human connection at the heart of the project, rather

than insulate visitors from each other with apps, audio guides, and other forms of information-transfer technology. Perhaps also that we need to shift from viewing the visitor as a passive consumer of information requiring guidance to considering them as an intellectual (and even biological) resource, bringing questions, ideas, and experiences from a unique perspective.

Before we delve into the possible futures of spaces to engage the public with science and technology, we should take a look back at where our existing public-facing science institutions have emerged from.

During the sixteenth century, a growing group of European collectors and "cognoscenti" from Ulisse Aldrovandi in Bologna to Emperor Rudolf II in Prague demonstrated their distinction by creating *Kunst- und Wunderkammern*, where oddities of nature—including monstrous hybrids and remarkable plants discovered on expeditions to the Americas—were included alongside marvels of art and instruments of science. Such spaces were never for the public, but for invited guests, or distinguished visitors often armed with royal letters of introduction.

In the seventeenth century, when such cabinets were already going out of fashion in Italy, astronomer Galileo Galilei witheringly described entering "the study of some little man with a taste for curios who has taken delight in fitting it out with things that have something strange about them, either because of age or because of rarity or for some other reason, but are, as a matter of fact, nothing but bric-a-brac—a petrified crayfish; a dried-up chameleon; a fly and a spider embedded in a piece of amber; some of those little clay figures which are said to be found in the ancient tombs of Egypt; and, as far as painting is concerned, some little sketches by Baccio Bandinelli or Parmigianino."[10]

Gradually from the mid-seventeenth century, art collections began to separate out, and the "wonders" fell gradually into neglect,

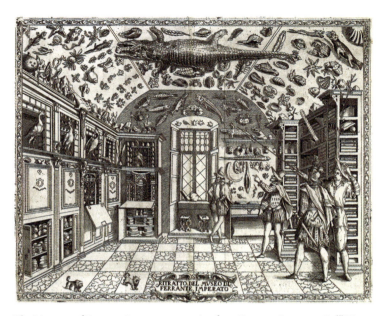

The Museum of Ferrante Imperato, engraving from Ferrante Imperato, *Dell'Historia Naturale* (Naples, 1599). *Source:* Wikimedia Commons, https://commons.wikimedia.org/wiki/File:RitrattoMuseoFerranteImperato.jpg.

with early art museums open to the public such as the Uffizi, the Louvre, and the Capitoline museum in Rome coming into existence in the eighteenth century.[11]

Modern science museums and natural history museums, on the other hand, were conjoined twins born of the industrial revolution. The London Science Museum was a direct by-product of the Great Exhibition of the Works of Industry of All Nations of 1851. The Berlin *Museum für Naturkunde* opened at its impressive new premises in Invalidenstrasse in 1888, having had an existence as a university museum since 1810. On one side of the museum was the Royal Prussian Mining Academy, on the other side the Royal Agricultural Academy of Berlin with its agricultural museum,

inviting the comparison between the scientific investigation of nature through collection of specimens, the extractive industries, and the domestication of nature through agriculture. The museum is now undergoing a radical transformation to create a new campus linking life sciences and society under the leadership of Johannes Vogel.

Just down the street from Berlin's *Museum für Naturkunde*, Urania, inspired by the vision of Alexander von Humboldt, existed from 1888 to 1928 and offered a public astronomical observatory, a science theater, and a hall of about 100 hands-on science exhibits, many of which could be operated by push-buttons.

Push-button interaction with models and demonstrations was also a key feature of the sprawling Deutsches Museum in Munich, launched by Oskar von Miller in 1903 as the "German Museum for the Masterpieces of Science and Technique." The Deutsches Museum also opened the world's first modern planetarium in 1924, and was highly influential in the creation of the Museum of Science and Industry in Chicago by Sears, Roebuck Chairman Julius Rosenwald, and also on many other new science museums around the world such as (although they would never admit it) Paris's Palais de la Découverte, which opened in the context of the Exposition Universelle des Arts et de la Technique of 1937.

In addition to science museums, natural history museums, and public observatories and planetariums, another strand of public engagement with scientific topics emerged with a stronger focus on events and popular lecture demonstrations. Perhaps most famous among these were London's Royal Institution Christmas Lectures, advertised in 1825 as a course of lectures "on some of the leading branches of Natural Philosophy, adapted to the comprehension of a juvenile auditory," and made famous by the theatrical public lecture demonstrations of Faraday and Tyndall.[12]

In the late nineteenth and early twentieth centuries, museums of science and industry emerged as an important "soft power"

channel for nation-states and industrialists, demonstrating technical superiority and serving as enthusiastic cheerleaders for the marriage of science and industrialization.[13]

During the Cold War period, this atmosphere changed significantly. Frank Oppenheimer's project to create the Exploratorium in San Francisco was an effort to return to a curiosity-driven state of exploration of phenomena, uniting scientists and artists in a state of wonder. Oppenheimer was profoundly affected by his and especially his brother Robert's role in developing the atomic bomb, and saw the need to bring science back to an Edenic, almost childlike state of curiosity. A victim of McCarthyism, Oppenheimer saw the noble work of the scientists involved in the Manhattan Project as perverted by external forces of history and society.[14]

He succeeded in opening the Exploratorium and its many interactive exhibits without any backing of government or industry, but with just $50,000 from the San Francisco Foundation and through a remarkably bottom-up, "home-made" process, meaning that he was also under no obligation to place the technical achievements of industry on a pedestal, something that gave the early Exploratorium a very different atmosphere from other museums of science. Situated in the cavernous setting of the Palace of Fine Arts in San Francisco, built in 1915 for the Panama-Pacific Exhibition, the Exploratorium was neither a promotional platform for technical achievements nor a forum for vocal social and political critique of industrialized or militarized science, but a place blissfully free of either. Its hands-on exhibits were nonetheless generally intended to allow visitors to discover certain scientific principles for themselves, so it was a pedagogic project at its core, albeit based on Oppenheimer's philosophy of playful learning through hands-on interaction.

Many Exploratorium exhibits bore a striking resemblance to the kinetic art works and op art works of the 1950s and 1960s, and

artists played a key role in Oppenheimer's vision of a museum of perception. The pioneering ICA exhibition Cybernetic Serendipity, also discussed later, was presented at the Exploratorium in its first year and helped fulfill Frank Oppenheimer's goal to have artists' work in the museum, while also providing much needed content for the floor. As Oppenheimer said with characteristic enthusiasm, "Cybernetic Serendipity was indeed a most important beginning for our place. It really set the stage for the kind of work we wanted to do because it combined perception, art, technology and science in a wonderful way."[15]

Prior to the opening of Exploratorium, the exhibition *Mathematica: A World of Numbers . . . and Beyond*, created by designers Charles and Ray Eames with support from IBM, which opened at the California Museum of Science and Industry in 1961, had a key role in presenting a new approach to exhibition design, with many hands-on interactives demonstrating complex mathematical concepts.

Ontario's science center opened just a few weeks after the Exploratorium, also with a strongly interactive approach, but with more of a science and technology focus, rather than the Exploratorium's expansive vision to be a museum of human awareness and perception, involving artists and psychologists alongside physicists in creative exploration.[16]

While the Exploratorium spawned imitators around the world, from Paris to Beijing, through the Exploratorium Cookbook (an "open source" guide to assist with replication of Exploratorium exhibits) and a rapidly expanding business of building clones of its interactive exhibits, many of its essential ingredients remained lost in translation when removed to other locales. The prominent "shop" at the heart of the Exploratorium, where exhibits were built in public view and then tested out on the floor, was rarely included in Exploratorium spin-offs around the world, which

preferred to buy their interactive exhibits ready-made and pre-tested, and overlooked the need to maintain, repair, and improve their exhibit collection. The exploratory cooperations with artists, psychologists, and scientists and the art residency programs of the Exploratorium were often not understood as essential resources for innovative, attractive, and scientifically relevant work in the interactive science centers that popped up all around the world in the 1980s and 1990s. Instead they tended to focus on replicating the seductive hardware—the interactive exhibits—rather than on the hidden root system that ensured a constant influx of new projects and ideas. There are now, as of 2020, over 3,000 interactive science centers in the world, with large network organizations festooned with acronyms (ASTC, ECSITE, ASPAC, RedPOP, NAMES, SAASTEC) and hosting world summits bringing their leadership together to share activities and approaches, sell each other touring exhibits, and issue lofty Declarations, Statements and Protocols.[17]

While far-flung and embedded in very different cultural contexts, many of these interactive science centers, it must be said, look remarkably similar to one another, and in many cases include copies of the same interactive exhibits, many of which can trace their genetic origins back to the Exploratorium. In turn, many interactive exhibits of the Exploratorium could trace their origins to modified physics demonstration devices used in university classrooms and lectures.

Like the Victorian-era natural history museums or the museums of science and industry birthed from the worlds' fairs celebrating triumphs of engineering, the rapidly spreading science centers popping up around the world inspired by the Exploratorium encapsulated a specific image of science, embodied by self-guided interaction and playful discovery. Science was about exploratory play, individual curiosity, and direct experience through hands-on interaction with "phenomena" of the natural world embodied in

purpose-built interactive exhibits carefully presented for maximum accessibility.

This image of science as "fun" was very distant from the reality of physics research in postwar America, which as David Kaiser has shown, had lost much of the curiosity-based philosophical spirit of open-ended exploration, and in the shadow of the mushroom cloud Oppenheimer created, a magical Neverland of science as-it-should-be rather than science as-it-is.[18]

The interactive science center approach was taken a step further and articulated afresh in CosmoCaixa, the science museum founded in Barcelona by physicist Jorge Wagensberg, who argued that the only three things that belong in a science museum are real objects (for example, fossils), real phenomena (for example, soap bubbles forming a minimal surface foam structure), and what he called "museographic metaphors"—namely the representation of invisible natural process through a simulacrum or, as Wagensberg puts it more poetically, "a combination of objects and phenomena that is capable of making visible an invisible slice of reality"—for example, an illustration of Brownian motion through blowing ping-pong balls.[19]

CosmoCaixa, which first opened to the public in 1981 but was hugely expanded and reopened in a new building in 2004, combines elements of the science center, the aquarium (with its spectacular flooded Amazonian rainforest), and the natural history museum under the banner of Wagensberg's uncompromising "total museology."

While the interactive science centers that spread around the world in the last decades of the twentieth century were generally quite successful in stimulating the curiosity and interest of children, the playful brand of hands-on science they purveyed sometimes struggled to engage older teenagers and adults to the same degree. As Sir Neil Cossons has put it,

When young people themselves view science as something they finished with as children, small wonder that puberty appears to be the great enemy of the public understanding of science. Science centres, set up to inspire and engage, may in fact be laying the ground for a conscious and forthright rejection of science by the young once they become aware of more appealing alternatives.[20]

By largely insulating science from the ebbs and flows of culture and politics and presenting apparently universal phenomena, science centers as originally conceived, and even in the reinventions of Wagensberg and others, are ill-adapted to presenting the interconnections between science and other areas of culture, to presenting contentious or controversial science, and to tackling complex science-related or environmental concerns of the public.

There is arguably still a place for interactive hands-on science centers in our society, but also for a case for a much greater variety in our public spaces for encounters with science. It would be a very strange situation if you travelled the world over and all of the arts and cultural centers looked pretty much the same, but that has been pretty much the case for our science centers, and limits our engagement with science to a form of ritualized play.[21]

We suffer from the strange but very pervasive preconception that science museums and centers are "for children" and art galleries are "for adults." Why should this be the case? Especially in times when ignorance and denial of science are becoming a dominant position in politics, it seems that it is increasingly important for people to understand that science is for adults, and not a childish thing, to be put away along with Santa Claus or broken toys. But where are the spaces that draw young adults and adults into a meaningful conversation about the future direction of science? About the cultural, political, and ethical dimensions of science? And about the relevance of science for society? About how to navigate "wicked problems" such as climate change and ecosystem

collapse? How might new kinds of spaces and approaches evolve to reconnect science and culture and reach new audiences in addition to the school and family groups addressed by most science museums?

2
Three Tales from the Future

What could the science museum of the future look like? I would like to describe to you three fictional scenarios for the near-future evolution of the science museum—the megamuseum mall, the cloud chamber, and the invisible museum.

1 The Megamuseum Mall

The megamuseum mall is a branded science museum complex which is located in vast iconic buildings designed by starchitects in Abu Dhabi, Shanghai, Riyadh, São Paulo, Las Vegas, and Singapore. It is designed to accommodate high rates of visitor flow, and has 3-D gestural guides allowing for state-of-the-art interactive presentation of information, integrated with targeted advertising using face-recognition responding to visitor profiles harvested from social media. AI permits emotion-tracking of visitors during the visit, allowing personalized recommendations. Immersive exhibits celebrate the achievements of science and technology, providing an integrated tourist experience, and the museum is integrated seamlessly with a large shopping mall complex in each location. Blockbuster exhibitions on themes such as space, dinosaurs, and human bodies travel between museums in the franchise, which also provide next-generation immersive media experiences, hotels, and a wide range of attractive food and beverage options. Production values are polished and ticket prices are pegged to theme-park entrance rates—the megamuseum mall is the Cirque de Soleil of the science museum world. It is a vehicle for the new soft power of large corporations and nation-branding, bringing the Bilbao effect to science.

2 The Cloud Chamber

The second speculative scenario, the cloud chamber, is a throwback to the seventeenth-century coffeehouse—a place for conversation

and creation. It is a local affair, drawing on the science, technology, and artistic/design communities in the neighborhood. It is a space for biohackers, makers, engineers, and designers to converse and co-create, where there is no clear boundary between visitors and creative core, but where everyone who drops in has an opportunity to contribute, through hackathons, events, and workshops. It is located in different kinds of structures in different locations, from shop fronts to extended cafes and warehouses, drawing its character from the local creative community. It is a vibrant place for debates, events, performances, and a place where you can "connect the unexpected" through ongoing experimental projects. It serves as a physical focus for different local communities, from citizen scientists to speculative designers to entrepreneurs and educationalists. It has residencies and labs where long-term collaborative projects can be generated, and is highly networked with other kindred organizations. It is a place not just to show research but to do research and create new work and projects as well. More and more research and innovation takes place outside universities and in these less formal creative spaces. Some people revile these spaces as being dominated by an "in-crowd," but others find an unexpected route to participation in science.

3 The Invisible Museum

The third scenario, the invisible science museum, is generated following the recognition by governments that science museums are a legacy of the pre-COVID-19 past—they are no longer safe, relevant, or required due to the immediate availability of up-to-date scientific knowledge on mobile and embedded devices. As the various natural history museums and science centers have their collections digitized and dismantled, a number of experiments take place in using mobile devices to turn any location into a site of

informal science learning, from augmented reality urban-foraging to sensor-enhanced citizen science projects on water quality or smog. A competitive market emerges for informal science learning apps. School "science" trips become extended field trips for contributing data to citizen science projects, and schools are rewarded with increased government funding, derived from the savings made from shutting down the museums, based on their data contribution to large-scale scientific research projects. Every citizen has the duty to contribute to science, through participation in citizen science projects and daily harvesting of their personal physiological and health data. Data quality is very variable, however, and researchers need to invest significant effort to weed out valid experimental data, and begin to design experiments that depend less and less on the intelligence of the individual citizen scientist, ushering in a new age of "rote experimentation." Even animals are coopted as participants in the new age of citizen science—with birds and even insects serving as flying sensors, participating in the expanding "Internet of Animals," providing climate data and assisting in early warning of new pandemics.

Zeppelins and Airplanes

While these are all rather plausible scenarios (arguably more caricatures of existing trends), the premise of our three scenarios is flawed. There is no one-size-fits-all model of the science museum of the future to which we should aspire. Indeed, that would be to inherit one of the key problems of the interactive science center model: its tendency towards universality, at the expense of local relevance.

Instead, the best situation for the public is arguably one of a large variety of different models and approaches, allowing different audiences with different interests to identify the experience that is

most relevant and engaging to them.¹ An analogy can be found with the early days of human flight. Just over a century ago, at the dawn of the age of flight, it was still unclear whether lighter than air travel (airships) or heavier than air travel (airplanes) would ultimately dominate. Zeppelins were expensive, imperialistic, state-funded, and generally carried large groups of important dignitaries from place to place. There were only a handful of existing designs. If a zeppelin failed, it was catastrophic—a hundred prominent people died. The earlier airplanes were developed by passionate amateurs; they experimented with over 100,000 wildly different designs. They failed cheaply—in the worst-case scenario, one plucky hobbyist died dramatically. The result was a Darwinian proliferation of different designs.² So the question becomes: how can our future science museums be less like zeppelins—bloated vehicles of imperialism—and more like early airplanes—experimental, entrepreneurial, adaptive? How can we stimulate a Cambrian explosion of new approaches to connecting the public with science?

In a sense, such an explosion of new approaches has already been happening, although the new life forms have been primarily emerging from outside the science museum field.

Let me introduce some of these (new and old) life forms:

Science Festivals

Science festivals are now relatively commonplace around the world, from the Singapore Science Festival to the China Science Festival in Beijing, to the Cambridge Science Festival in Massachusetts, and the World Science Festival in New York. The Edinburgh Science Festival was the original of the species, founded in 1989, and at the time the very idea of a "science festival" appeared somewhat radical and counter-intuitive. How could a festival format, developed for theater or music, be appropriate for the serious business of science?³

Edinburgh, a city that already knew how to pull off a festival, quickly inspired many other science festivals, and the transformation of once rather stuffy insider gatherings such as the annual meeting of the British Association for the Advancement of Science into festivals (the latter now claims to be Europe's first science festival, *avant la lettre*). At one end of the festival spectrum, the glitzy World Science Festival in New York, founded by string theorist Brian Greene and news journalist Tracy Day, features premieres of Philip Glass operas about relativity theory and features Hollywood stars such as Alan Alda in its red-carpet gala events in Manhattan. At the other end of the spectrum, the Pestival in the UK is a very unusual festival of "the art of being an insect" and was described by the *Guardian* as the "Glastonbury of the Insect World." We now even have dedicated science film festivals, such as the Imagine Science Film Festival, also expanding globally. STATE, Berlin's Festival for Open Science, Art and Society, was founded by a group of people involved in the Berlin nightclub scene who happened to be scientists, but also really knew how to throw a party. Other science festivals placed a stronger emphasis on the interplay between science and literature, such as the Genoa Science Festival founded by Italian publisher Vittorio Bo.

In addition to the emergence of dedicated science festivals, we have seen science-related events intruding more and more into the programs of arts, cultural, and rock festivals. Guerilla Science has been a pioneering organization in this regard, bringing science to Glastonbury and beyond with playful and sometimes risqué exhibits for adult festivalgoers being a specialty, ranging from the Sensorium to the "Lube Lab," which invited brave or inebriated festivalgoers to clamber into a giant vagina to probe the science of lubricant.

The seminal Ars Electronica Festival, founded in Linz as a media arts festival back in 1979, now dedicates extensive program space to science, including collaborations with CERN and the

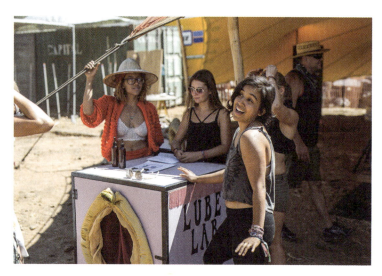

World's Smallest Lube Museum—a mobile cart charting the historical evolution of lube—created by artist Jaade Wills (left, in red) and scientist Dezirae PeBenito (right, foreground) as part of Guerilla Science's residency at the Oregon Eclipse Festival. *Source:* © Guerilla Science.

European Commission STARTS program (innovation at the nexus of science, technology, and the arts), and art-science "hybrid arts" projects.

Many science museums and centers now routinely bring their pop-up content to festivals, or even play a key role in founding and organizing local science festivals, as, for example, the MIT Museum does for the Cambridge Science Festival.

There are some features of festivals which provide them with certain advantages over other forms of science engagement.

First, because they are ephemeral, they are ideally suited to tapping into current discussions and issues. A festival cannot "fall back on the hardware" of permanent exhibits, but is forced to stay edgy and rely strongly on the software—the human interactions.

Second, festivals are highly sensitive to audience demand and needs. People can simply walk out if they get bored. This is especially true of the paid festivals, where science-related activities are competing for people's time and attention with big-name acts. Where science museums can survive reasonably well on enforced visits from school groups, and capturing families looking for something to do with the kids on a rainy Sunday, festivals are unforgiving of dull, familiar content, and this forces those developing events to make them relevant, engaging, and of the moment.

Third, festivals are by their nature places of serendipitous human interaction, and especially well-suited to permitting unexpected juxtapositions of people and ideas.

Festivals are certainly not without their disadvantages—they are noisy places ill-suited to activities requiring sustained concentration. In the cases of the larger music festivals, there really are limits to what you can do to connect people who are drunk or on drugs with science. And the larger festivals, from Burning Man to Glastonbury, with their glamping utopianism, can be playgrounds of the privileged. While they may well be a valuable mechanism to connect with groups of people (including young adults) who would never dream of entering a science museum, such events are possibly not the most effective mechanism to engage the least privileged sectors of society with science. However, science festivals that adopt a truly "citywide" curatorial approach—going out to where people already are, rather than expecting audiences to come to them—combined with strong engagement with schools and local community groups can hope to reach a more diverse audience base. Successful festivals are ultimately also elaborate and costly productions, requiring significant human and financial resources. However, most festivals did not start big—even Burning Man began with 20 people on Baker Beach in 1986, and is now a

festival of 40,000 people. Festivals arguably require a very different skillset and mindset from traditional science museums and science centers, but rather than a disadvantage, that might be seen as an opportunity to bring greater dynamism and a strong events focus into our museums.

In spite of their shortcomings, I would strongly encourage anyone planning on creating a new science center or museum to first begin with a festival, as a way to gradually prototype ideas with the public, build relationships that will support it in the long term—both intellectually and financially—and grow an engaged community. The Copernicus Science Centre in Warsaw grew out of the successful annual Science Picnic. The Ars Electronica Festival in Linz led to the creation of the new Ars Electronica Centre in 2009. When permanent institutions fall out of festivals and ephemeral events, it helps ensure that the institution has a pulse and is strongly connected to its community from the outset.

The Maker Movement

In 2005, *Make Magazine*, created by Dale Dougherty and O'Reilly Media (alas recently discontinued), published its first issue, proclaiming a new DIY movement of "makers." The following year, the first Maker Faire event was held in the San Mateo Fairgrounds, in the Bay Area, bringing together a motley crew of robotics enthusiasts, amateur scientists, and pyromaniacs. Since then, the "maker movement" expanded rapidly to include a huge variety of global events and gatherings, and maker spaces emerged to serve amateur tech enthusiasts. In some ways the maker movement was a natural heir to and rebranding of the 1950s DIY mechanics movement encapsulated by magazines such as Popular Mechanics, and also to the tradition of meet-ups like the Homebrew Computer Club in the Bay Area, where the Apple computer was first shown by

[handwritten annotations at top: "Partner w/ Futurium Berlin E-T.E.C. TEC. SF Exploratorium Technology Experience Center"]

Steve Jobs and Steve Wozniak to a group of computer enthusiasts.[4] Networks of commercial maker spaces such as TechShop have sprung up, offering annual subscriptions to enthusiasts, providing access to tools and expertise. It was in a TechShop, for example, that Twitter CEO Jack Dorsey made the prototype of his mobile payment device Square. Robert Hatch, CEO of Techshop, said, "This is what happens when you give people access to the tools of the industrial revolution. They change the world."[5]

The maker movement, which had many precedents such as the MIT concept of FabLabs, Intel Computer Clubhouses, and other such DIY spaces, is strongly associated with a discourse of democratization of technology and engineering, by providing everybody with access to the tools to make just about anything in their spare time, tools that were previously only available to large corporations, and then offering platforms through physical "faires" and publications to allow people to show off their cool DIY projects to others.

Building your own 3-D printer to print intricate designs with chocolate is a typical example of a maker activity. Making is framed as a virtuous, inclusive, bottom-up, family-friendly, noncommercial activity, where all are invited to make, and multibillion-dollar technology companies show their projects alongside garage scientists, remote-control boat hobbyists, and drone enthusiasts. Technology is liberated, dismantled and reassembled in the hands of the people. Making is also a family-friendly activity. Maker spaces and FabLabs have been rapidly integrated into science centers and museums, which have also become prominent as host organizers of maker faires and events. The incorporation of FabLabs into science centers and research institutions has sometimes been negatively received. For example, Unabomber-wannabe vandals in France burnt down the FabLab at the Casemate in Grenoble in November 2017, saying that it was "a notoriously harmful institution by its

diffusion of digital culture," and claiming that "city managers satisfy money-hungry start-ups and geeky geeks by opening FabLabs in trendy neighborhoods. These seemingly extremely heterogeneous devices all aim to accelerate the acceptance and social use of the technologies of our disastrous time."[6]

Making does not necessarily mean inventing, and to assemble a "food computer" or build a 3-D printer from existing instructions is as much a valid maker activity as inventing something completely new. The less family-friendly cousins of maker spaces, hacker spaces and hack labs, and also more recently bio-hacker spaces and DIY bio labs, have also emerged as anti-institutional, anti-corporate, and sometimes anti-government spaces providing access to tools and technology, and they serve as a community focus for those interested in creative uses of technology.

Whatever your views on the merits of 3-D printed chocolate sculpture, the maker movement pulled off one brilliant trick. They figured out how to harness individual pride and personal ownership in creative projects, and to provide it with a local and ultimately global platform. Maker events are not curated by an elite group of cognoscenti and tastemakers. They are presented as open opportunities where anyone who is passionate about making things can get involved and present their homemade rockets, cocktail-making robots, or, as I once witnessed personally, their project to lift a small child into the air with large numbers of helium-filled balloons (the parents intervened after the child reached head-height). It is karaoke night for technology, amateur hour for engineering, and an opportunity to gain kudos from other amateurs in showing off your latest invention to the world. The maker movement invited the public into the workshop, rather than simply presenting them with ready-mades to play with.

Science Fairs and Competitions

Not a new form of life, but a more institutionalized, optimistic approach that has been harnessing this sense of personal ownership for a much longer time are the science fairs and competitions, involving armies of high-school students earnestly manning their homemade table-top demonstrations, painstakingly drawn diagrams, and colorful hand-written explanatory texts.

The 1950s and 1960s saw competitive science fairs emerging in the United States as a defining cultural form for the Sputnik generation with the US National Science Fair launching in 1950, more recently morphing into the Intel International Science and Engineering Fair.[7]

Recently following Intel's example, Google launched its own science fair, demonstrating the perennial appeal of these competitive formats for those science and technology companies and governments who have an interest in drawing high-performing students into the "talent pipeline" and attracting them into courses and careers in science and technology. Patrick Collison, one of the world's youngest self-made billionaires and founder and CEO of Stripe, a $35 billion valuation (at time of writing) payments company, first came to attention at age 16 with his winning project "Croma: a new dialect of Lisp" at the BT Young Scientist Competition in Dublin in 2005.

Similar to other types of competitive activity for schoolchildren, from Irish dancing competitions to spelling bees, science fairs are often beset by challenges of becoming proxy wars for over-competitive parents and teachers, placing sometimes unrealistic expectations on children and involving overbearing adult input.[8]

A different type of science contest is the Science Genius BATTLES (Bringing Attention to Transforming Teaching, Learning, and Engagement in Science) contest created by Wu-Tang

Clan artist GZA, where urban students from New York City public schools who are traditionally disengaged from science in the classroom are invited to create science-themed raps, bringing their enthusiasm for hip-hop culture to bear on science, spawning some remarkable lyrics:

> DNA, deciding to never agitate or detonate
> Holding all of your fates but wait
> It's the double helix, lifes remix
> Deoxyribonucleic acid
> Watson and Crick mastered
> You're flabberghasted
> DNA, the instructions for making a protein
> Several amino acids one of them is named proline
> 46 chromosomes, pairs 23
> DNA has a codon, sequence of it is 3[9]

While they share some drawbacks with other competitive school-based activities, perhaps the greatest value of science fairs and contests lies in introducing a sense of personal agency to traditional school-based science, making a dent in the system of exam-focused, instruction-based learning by providing students with the idea that they too can make a contribution to knowledge.

The New Science Storytelling

Through the potent cocktail of spoken word events combined with streaming video and social media, with platforms like TED and Ignite by no means restricted to science, millions of people are being engaged with new forms of science-based storytelling, with science-dedicated formats like Story Collider having emerged in recent years. Such platforms are allowing new science heroes to emerge from outside of the normal hierarchies of the science

establishment. Younger or fringe figures who master the medium may gain far greater followings than Fellows of the Royal Society.

Consider Elise Andrew, founder of the Facebook page *I Fucking Love Science*, followed by over twenty-five million people, who left university after a bachelor's degree in biology but enjoyed sharing weird science stories and photos with her friends, and is now arguably one of the world's most influential communicators about scientific topics.

Or consider Michael David Stevens, armed with a bachelor's degree in psychology and English literature, and now the world's most prominent science YouTuber, with over fifteen million followers for his Vsauce channel, and his mini-documentary-style videos regularly receiving over five million views.

Another of the most popular science YouTube channels, the German *Kurzgesagt*: In a Nutshell, with over eleven million subscribers, creates entertaining animations telling science stories about viruses and black holes.

Even the most social-media-friendly celebrities of traditional science communication, like the ever-communicative Richard Dawkins, struggle to compete with such storytellers in these media.

If science museums are to remain relevant, they could do worse than to look at the Field Museum in Chicago, which hired Emily Graslie, a young museum volunteer who enjoyed creating science-related YouTube videos as "Chief Curiosity Correspondent." Her Brain Scoop YouTube channel now has over 550,000 subscribers. Her video on the venom of bullet ants has been viewed over two million times. Her work demonstrates a symbiosis between museum and YouTuber, where the museum provides an almost endless source of stories of natural wonders, and Graslie helps the museum reach very different audiences (young adults particularly) than its traditional visitors, and very likely attracts new audiences to visit the physical museum.

Are these new platforms trivializing science in search of clickbait? Probably. Are they vulnerable to pseudoscience, oversimplification of complex issues, and silver-tongued quackery? Certainly. But these challenges aside, they are clearly creating audiences (often young adults and adults) for lively scientific content that were previously untapped.[10]

Science storytelling is arguably old wine in new bottles, an ancient fireside art being revived in new media, but a beautiful narrative is very different from a genuine embodied conversation. Many more traditional science museums persist in trying to use their buildings to tell very detailed stories about science on the walls, providing visitors with 30,000-word books to be read awkwardly while standing up, texts that are universally ignored by visitors. Perhaps the extraordinary success of online science storytelling suggests that rather than trying to compete as storytellers with more appropriate media, science museums should focus more on the opportunities provided by serendipitous, embodied human interactions, and the equally noble art of conversation.

Citizen Science

After the 2011 Fukushima nuclear disaster, Japanese citizens in the area began making radiation measurements. One Buddhist priest, Sadamuro Okano, whose temple was in Serenji in the Fukushima region, had already developed an avid amateur interest in measuring radiation levels since the Chernobyl disaster. After Fukushima he noticed that radiation levels shot up to 50 times the baseline level. When the radiation-monitoring site SafeCast was created, there was a tool for Okano and others like him to pool their radiation measurements together. Geiger counters were attached to cars (inspired by Google's Streetview) and to the roofs of houses and temples. Networked counters could be purchased as kits and

easily assembled at home. Now SafeCast has over 3,000 counters worldwide in 90 countries.

In August 2016, a previously unknown cluster of galaxies was discovered by a group of amateur astronomers on the citizen science online platform GalaxyZoo.[11] In 2010, a class of twenty-five English schoolchildren aged between 8 and 10 co-authored a research study in the journal Biology Letters based on their experiments on bumblebee cognition in collaboration with neuroscientist Beau Lotto. According to the paper's abstract, "They asked the questions, hypothesized the answers, designed the games (in other words, the experiments) to test these hypotheses and analysed the data. They also drew the figures (in coloured pencil) and wrote the paper."[12] Beau Lotto's experiment in scientific co-authorship with schoolchildren drew on his educational work when invited to house his lab at the Science Museum in London.

Citizen science is the term which has been coined to describe the involvement of non-experts in generating scientific knowledge, whether to protect personal health, as in the case of SafeCast, or driven by curiosity and the potential for a small piece of scientific glory. From more passive activities like SETI or Folding at Home, where one simply permits one's computer to be enlisted in the search for extraterrestrial intelligence or protein folding, to the active participation in BioBlitz events to map local biodiversity, citizen science is, like the maker movement and DIY biology, perceived as a democratization of science, liberating it from being the exclusive preserve of the priesthood and allowing "average" citizens to make significant discoveries and contribute to research.

Citizen science apps and sites such as Zooniverse and iNaturalist count millions of active volunteer users devoting huge numbers of person-hours to contributing data. Citizen science projects rarely completely remove the need for expert oversight and are often beset by intractable problems of quality control—the

best projects seem to design strong conditions for cooperation between amateurs and professional scientists.

The museums of natural history have been quick to mobilize around citizen science, with museums such as the California Academy of Sciences in San Francisco and the Museum für Naturkunde in Berlin playing international leadership roles in establishing events such as the City Nature Challenge. Natural history museums, in distinction to less research-driven science museums and centers, have remained strongly focused on their research missions, putting them in a strong position to benefit from citizen science observations.

The future of citizen science lies in going beyond the already significant power of the smartphone, as in Fukushima, where necessity was the mother of invention, and in equipping citizens with different kinds of cheaply available sensors—from measuring air quality to sampling DNA of insects. The quantified-self movement—life-logging, and use of Fitbits and other wearables to monitor physiological activity, rapidly expanding to include other health data, such as insulin levels—is also becoming an increasingly relevant form of citizen science. Future museum visitors may be harvesting more and more of their personal health data. How can museums connect with this trend towards personalized health and monitoring?

Artificial intelligence is also likely to play a key role in accelerating the next generation of citizen science projects, with citizens helping to train algorithms to identify different species and galaxies. And citizen science is expanding its scope to include the observations of nonhuman citizens, through the growing "internet of animals," bio-logging projects inviting nonhumans armed with miniature tracking devices to contribute to scientific data collection.[13]

So, coming back to our three scenarios, the megamuseum mall, the cloud chamber, and the invisible museum, what kind of science museums can we hope to see in the future? Let us simply hope that rather than dominance of any of the three scenarios described above, or some new vision not yet imagined, we might see an explosion of a myriad of brave experiments, combining some of these features of the changing landscape of science engagement, and seeing existing museums and science centers inviting many of these activities into the tent to avoid becoming rapidly obsolete.

3
Rise of the Hybrids

Art and Science

> "It is with pi mesons and the most gelatinous and indeterminate neutrinos that I want to paint the beauty of the angels and of reality."
> —Salvador Dalí, *Anti-Matter Manifesto* (1958)

The previous chapter focused primarily on emerging trends in the world of science engagement and science communication, but many of the most exciting recent experiments in relation to science in public are coming through interactions with very different cultural fields—including the arts, design, innovation, and the humanities.

We are living, as designer Neri Oxman has said, in the "Age of Entanglement," where art and design, science and technology should not be seen in isolation but as part of a constantly cycling metabolic system, a Kreb's Cycle of Creativity, as she puts it.[1]

There's nothing new about the idea of bridging art and science. The use of artistic techniques in scientific inquiry and the use of scientific techniques by artists has a deep history. Perhaps Leonardo da Vinci has become the poster child of transdisciplinary thinking, but you could easily push the connection of art and science back a great deal further if you consider, for example, Pythagoras's application of mathematics to musical harmony in the sixth century BC, an application of number to the physical world without which all modern physics would arguably have been impossible.

The postwar period saw a raft of new cultural and pedagogical experiments occurring at the boundaries between art and science—the educational experiments of Black Mountain College in North Carolina, where Bauhaus emigré artists like Joseph Albers collided with physicists and designers like Buckminster Fuller. In 1950s London, "Gaberbocchus Thursdays" were genteel domestic art-science salons in the basement of the Gaberbocchus Press in Maida

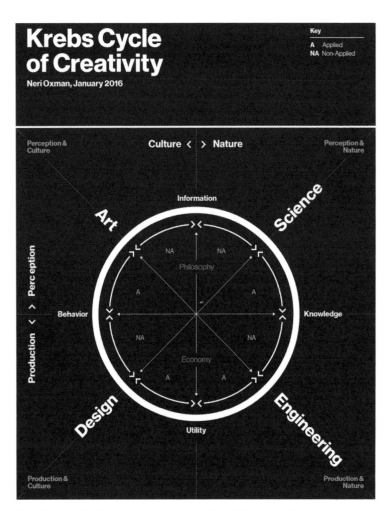

Neri Oxman, The Krebs Cycle of Creativity, from "The Age of Entanglement," *Journal of Design Science* 1, January 13, 2016. *Source:* © Neri Oxman, Media Lab.

Vale, featuring screenings of films about crystal growth and drop formation alongside discussions of art and science accompanied by wine and spaghetti.

In 1958 Salvador Dalí wrote his *Anti-Matter Manifesto*, claiming

> In the surrealist period, I wanted to create the iconography of the interior world, the world of the marvellous, of my father Freud. I succeeded in doing it but today the exterior world that of physics has transcended the one of psychology. My father today is Dr. Heisenberg, it is with pi mesons and the most gelatinous and indeterminate neutrinos that I want to paint the beauty of the angels and of reality.

Several of Dalí's works from this period incorporate themes from particle physics or early genetics, such as his *Saint Surrounded by Three Pi Mesons* of 1956.[2]

In 1960s New York, Bell Labs engineer Billy Klüver created *9 Evenings: Theatre and Engineering*, a series of experimental events involving artists including John Cage and Robert Rauschenberg, where artists were enlisted to push the boundaries of engineering. According to Klüver, as documented by Arthur Miller in his book *Colliding Worlds*, "The artist's work is like that of a scientist. It is an investigation which may or may not yield meaningful results. . . . What I am suggesting is that the use of the engineer by the artist will stimulate new ways of technology and dealing with life in the future."

The experiments of Rauschenberg, Cage, Klüver, and others in *9 Evenings* and the subsequent events of EAT (Experiments in Art and Technology) were characterized by endless technical breakdowns and long delays, and must have been rather excruciating experiences for the audience.[3]

In London, Jasia Reichhardt's seminal *Cybernetic Serendipity* exhibition at the ICA in 1968 brought the worlds of art and cybernetics together in a powerful cocktail that attracted about 60,000 visitors and featured 325 artists and scientists. At the same time, in the Paris of the barricades, American kinetic artist

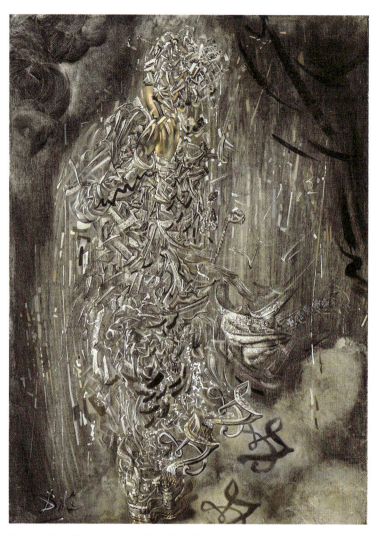

Salvador Dalí, *Saint Surrounded by Three Pi-Mesons*, 1956. Oil on canvas, 42 × 31 cm. *Source:* Fundación Gala-Salvador Dalí, Figueras, Spain.

and rocket scientist Frank Malina founded the highly influential art-science journal *Leonardo*, creating a key forum for presenting art-science work, which continues more than 50 years later under the leadership of his son, Roger Malina.

The 1960s were characterized by a sense of optimism and urgency about the importance of connecting art, science, and engineering to extend the senses, expand human perception, and help navigate new directions with emerging technology in the age of the mainframe. As Marshall McLuhan put it (in the casually sexist language of the time) in his 1964 classic *Understanding Media,*

> If men were able to be convinced that art is precise advance knowledge of how to cope with the psychic and social consequences of the next technology, would they all become artists? Or would they begin a careful translation of new art forms into social navigation charts? I am curious to know what would happen if art were suddenly seen for what it is, namely, exact information of how to rearrange one's psyche in order to anticipate the next blow from our own extended faculties.[4]

Here McLuhan placed artists in the role of an "early warning system" for science and technology, suggesting like Klüver that they can confront society with the consequences of emerging technologies even before they were fully realized. Simultaneously, McLuhan's contemporary, designer Buckminster Fuller, inventor of the geodesic dome, coined the term "Comprehensive Anticipatory Design Science," championing a new role of designers in anticipating entire future societies and complex systems, rather than just designing products. In parallel with the Cold War obsession with cybernetic early warning systems to detect incoming attacks from Russia by aircraft or missile, McLuhan and Fuller considered both artists and designers as essential early-warning systems for humanity.

This vision of a critical and anticipatory role of artists with regard to emerging science and its social consequences was quite

different from the role of artists, such as those involved in the early Exploratorium, in playing with fundamental natural phenomena and perception, or, as with Salvador Dalí, drawing ideas from nuclear and particle physics as part of a new visual language. While the 1980s and 1990s saw an explosion of so-called "new media art," including much early video art and computer art, it was really only in the early years of the twenty-first century that this anticipatory role of the artist began to crystallize.

In 2000, Eduardo Kac announced the creation of Alba, GFP Bunny, a rabbit with a jellyfish gene for green fluorescent protein inserted in its DNA, and causing the albino rabbit's fur to glow green under black light. Kac's glowing rabbit disappeared mysteriously and there has been much speculation over whether she ever really existed, although since then GFP rabbits aplenty have been produced by scientists from Istanbul and Hawaii.

In 2004, artist Steve Kurtz of the Critical Art Ensemble was arrested by the FBI on suspicion of bioterrorism. Kurtz had called 911 after his wife had a heart attack, and when the emergency services came to his home they discovered a home biolab, where Kurtz was preparing an artistic installation about agricultural biotech for the Massachusetts Museum of Contemporary Art. Kurtz, whose performance events sometimes involved "releases" of bacteria to audiences, represented a new kind of biological artist, directly using the tools and materials of biology as a critical tool around current discussions in relation to health and agriculture.

In 2007, after ten years of concocting the plan, Australian-Cypriot cybernetic artist Stelarc grew a "third ear" on a bio-compatible scaffold in a laboratory in Los Angeles, and then had it surgically implanted in his left arm. His goal was to have a Bluetooth microphone inserted in the "ear" to allow people all over the world to listen to him over the internet at any moment. Early on, the ear became infected, and Stelarc had to go to A&E.

He informed the hospital orderly that he had an "ear infection" and then proceeded to roll up his sleeve to show his extra ear. Unsurprisingly, the doctors were horrified and refused to treat him, but eventually he was treated, and the project to make his third ear "hear" is ongoing. Stelarc's ear-on-arm was a strange echo of a scientific ear-on-mouse project—the Vacanti mouse, the image of which was an early internet meme, going viral back in 1997 and provoking storms of opposition to genetic engineering, even though no gene manipulation was involved.

In 2003, guests at the Disembodied Cuisine dinner in Nantes, France had a chance to taste in vitro steak grown in a lab from frog tissue (what else?), an initiative of the Tissue Culture and Art Project of Oron Catts and Ionat Zurr. This artistic experiment occurred ten years before the first commercial in vitro meat was tasted with Mark Post's lab-grown hamburger (all lab-grown or substitute meat projects are now incarnated first as a hamburger rather than

Stelarc, *Ear on Arm and Prosthetic Head. Source:* © Science Gallery, Trinity College Dublin.

a less familiar form). Post's lab-grown €250,000 hamburger, grown in vitro from bovine muscle tissue, suffered from a fatal flaw of circularity—the nutrient solution required to grow the meat was made from fetal calf serum, an irony that artists Catts and Zurr delighted in pointing out as in vitro meat was hailed as an ethical approach to producing meat for animal lovers.

In 2011, after several months of preparatory injections of horse immunoglobulin, artist Marion Laval-Jeantet was injected with horse blood in the Kapelica art gallery in Ljubljana, Slovenia. Samples of her hybrid blood were extracted, freeze-dried, and placed in engraved aluminum cases. After the transfusion, the artist conducted a ritual while walking slowly around her donor horse on a pair of prosthetic hooves.

Not all "anticipatory art" is so gory though. Artist Natalie Jeremijenko's project *One Trees* created 1,000 clones of a tree and planted them at different sites around the San Francisco Bay Area. As the trees were clones, any differences in the way the trees grew would have to relate to "nurture," due to the environment in which they were located and the events of their lives, providing a simple but powerful way to provoke a discussion around genetic predestination.

Many of the works of the artists described above, representing only a tiny sampling of the artists working with science, are highly mediagenic—they provoke a strong reaction from the media, often bringing together the powerful emotions of fear and disgust. In some extreme cases, such as Kac's Alba, when you strip away the layers of media commentary, it is hard to see if there is anything left—upon closer analysis the white rabbit magically disappears, and you begin to wonder was it ever really there. Many of the projects above are also primarily biological, and it appears that works that confront us with our biological futures often provoke a more visceral response than exploring purely technological futures.[5]

Marion Laval-Jeantet and Benoit Mangin, *May the Horse Live in Me. Source:* © Marion Laval-Jeantet.

Even Gunther von Hagens's touring exhibition of plastinated bodies, *Body Worlds*, was originally conceived as an art exhibition, but mutated into a science exhibition due to the public concerns about use of human remains for art (science education was a much more acceptable goal, even if it sometimes just implied a few minor changes to the labeling used in the exhibition).

The Biennale art world, with its art fairs, round-spectacled collectors and curators, galleries, institutional investors, and dealers of the art market, has tended to relegate such projects, which often by their nature defy normal collecting and commercial practices, to the fringes, requiring the emergence of a different kind of support structure for their realization, linking universities and research institutions, corporations and foundation grants. The "objects"

Tomás Saraceno, Semi-social musical instrument SXDF-NB1006–2: built by four Cyrtophora citricola–eight weeks, 2015. Spidersilk, carbon fiber, and plexiglass. *Source:* Courtesy of Tomás Saraceno. © Photography by Studio Tomás Saraceno, 2015.

they produce are often fleeting events, experiments and rituals, debates and discussions, ill-suited to acquisition and containment.

Nonetheless, in recent years some artists have managed to make the bridge between the research lab and the art world—consider, for example, Tomás Saraceno's extraordinary artistic work on spider webs, developed through a deep collaboration with Alex Jordan from the Max Planck Institute in Konstanz, where the artists' studio itself enlists the help of hundreds of nonhuman helpers, in the form of social and nonsocial spiders creating highly complex web structures, which are then scanned in three dimensions.

Speculative Design

More recently, designers have been appropriating from artists this McLuhanesque role of artists to anticipate the psychic and social blows of the next technology, with the rise of speculative design and design fictions. From satellite communications to time travel and invisible materials, breakthroughs in science and technology have often been driven by the exploration of fictional scenarios.[6] Good science fiction requires the imagining of a future society, complete with new products and services, new rules of social behavior, and new ethical dilemmas. Often the extrapolation of a current social, environmental, or medical trend can help us to posit plausible alternative futures. For example, what if our overuse of antibiotics were to impact our resistance to disease to such an extent that we needed to transform our bodies, already hosts to a rich microbiome, into farms for drug development? Or what if climate change created a food shortage requiring humans to create an additional external stomach to digest cellulose, allowing us to eat pond algae? While scientists and engineers can expand the bounds of possibility, whether through miniaturized drug delivery promised by nanotechnologies or xenotransplantation techniques, whereby humans receive organ transplants from other animals, in order to translate the implications of these technologies into visceral reality we require designers to design products, tools, processes, and future services. Traditionally, industrial design has come into the story fairly late in the day, when technologies have already been black-boxed, and the designer's role is more one of applying a cosmetic finish to appeal to the consumer. What is exciting about the work of Anthony Dunne and Fiona Raby, and the generation of speculative designers that they have spawned, initially in the Royal College of Art in London and now in Parsons in New York, is that they have brought the design process upstream

and into engagement with the speculative stage in the development of new technologies, engaging in direct dialogue with scientists and engineers who do not yet know the practical consequences of their work. The result is an involvement of the designer in fleshing out the social and ethical consequences of emerging technologies before they happen, as an "early warning system" for future trends and a way to confront us with possible future societies, utopian or, more often, dystopian.

In 2012, Next Nature Network launched the company Rayfish Footwear, advertising to customers the chance to design their own sneaker incorporating the custom-patterned skin of a genetically modified fish, harking back to the prized material of shagreen. Next Nature then released CCTV footage apparently showing animal rights protesters breaking into the headquarters of Rayfish Footwear and removing the genetically modified fish before releasing them into the ocean, where they interbred with naturally occurring stingray, creating a host of new color palettes. Despite being a hoax, the company attracted global media attention and huge amounts of criticism from the media and the public. As Bruce Sterling puts it, this project is an example of how "we feel uneasiness when the nature brand is violated . . . when nature is slightly artificialized—say, by installing a park bench under a tree—we rarely get any dark suspicious frisson about that. The uncanny can only strike us when our ideological constructs about nature are dented. We're especially guarded about our most pious, sentimentalized notions of nature."[7]

In some ways you might say that from *Bladerunner* to *Black Mirror*, speculative design is an appropriation of the job of science fiction (or perhaps even more of what Margaret Atwood calls "speculative literature"), but there is something immediate about designing and prototyping new products and services that hits us in a different place than traditional sci-fi, forcing us to confront and

Anthony Dunne and Fiona Raby, *Designs for an Overpopulated Planet: Foragers,* 2009. *Source:* Photograph by Jason Evans.

discuss the possible scenarios that our technologies might engender. There is something very poignant and unsettling about the concept of an anti-smoking mask designed to protect your pet pig which is hosting your replacement pair of lungs, so that you can continue to smoke heavily as the pig lives in your house, being protected from your passive smoke until the moment of transplantation. What is wrong with this scene? Is this a world we really want to live in? By using design to ask these important questions, speculative design appeals to us as consumers, relating more to those self-defining, moral decisions we might make in the supermarket aisle or in the doctor's surgery than to our recreational consumption of science fiction.[8]

Latour and the Exhibitionist Turn in STS

Another development that has brought new approaches to presenting science in public is what one might describe as the "exhibitionist turn" of the transdisciplinary academic field known as Science and Technology Studies (STS).

Back in 1992, sociologist of science and historian Steven Shapin, one of the founding figures of STS, made an earnest plea for the public to gain opportunities to experience the messiness of "science in the making":

> I think that traditional exercises which seek to inform the public about *what scientists know* are undoubtedly important. Yet, in so doing, I think that another aspect of public education tends to be neglected, and that is *how, with what confidence, and on what bases, scientists come to know what they do.*

Shapin argued that the public should have the opportunity to experience the collective basis of science, the ineradicable role of trust in scientific work (a central topic in Shapin's writings on early modern science), the contingency and revisability of scientific knowledge, and the interpretative flexibility of scientific evidence.[9]

Laboratorium

In 1999, Belgian curator Barbara Vanderlinden and Swiss curator Hans Ulrich Obrist began assembling the ambitious Laboratorium exhibition in Brussels. A think tank was assembled to plan this as a citywide project "in which the scientific laboratory and the artist's studio were explored on the basis of the various concepts and disciplines." Participants included, among others, French sociologist of science Bruno Latour, artist Carsten Höller, and scientist Luc Steels. The discussion revolved around questions such as the following:

How can we attempt to bridge the gap between the specialized vocabulary of science, art, and the general interest of the audience, between the expertise of the skilled practitioner and the concerns and preconceptions of the interested audience? What is the meaning of the laboratories? What is the meaning of experiments? When do experiments become public and when does the result of an experiment reach public consensus? Is rendering public what happens inside the laboratory of scientist and the studio of the artist a contradiction in terms? These and other questions were the beginning of an interdisciplinary project starting from the "workplace" where artists and scientist experiment and work freely.[10]

Following Laboratorium, Latour, Peter Galison, Caroline Jones, and others teamed up with Peter Weibel at the Zentrum für Kunst und Medien (ZKM) in Karlsruhe to create ambitious exhibition projects. Going beyond Shapin's dream of bringing "science-in-the-making" to the public, Latour, Galison, and Weibel used exhibitions, especially *Iconoclash* and *Making Things Public*, as experiments—to address the "current crises of representation." *Making Things Public* was not just a public exhibition, but a manifesto for a new approach to bringing things into the political sphere—a new "Dingpolitik" which emphasized reorganizing politics around not affiliation to political parties, but matters of concern. Latour notes that representations and assemblies share the same etymology—they are both "things." Scientific laboratories, like parliaments and the Olympic Games, are also assemblies into which representations are introduced and debated, according to Latour.[11]

Sharon Macdonald and Paul Basu have examined the notion, characteristic of Latour, Galison, and Weibel's projects, of exhibition intended as public experiment, going beyond mere public display of information and objects. They argue that exhibition is increasingly conceived as a kind of laboratory, a site for the generation—rather than the reproduction—of knowledge and experience.[12]

New Spaces of Experimentation

In addition to these new approaches and trends to putting science on show, the first two decades of the twenty-first century have seen many new kinds of institutions with very different approaches emerging to support collisions between science and other areas of culture.

Zentrum für Kunst und Medien (ZKM), Karlsruhe
Clearly ZKM in Karlsruhe has emerged (particularly under Peter Weibel's leadership) as one important space to support such exhibition experiments, bringing scientists and sociologists into the role of curators and bringing science into clashes with art, philosophy, and politics. With such highbrow assemblages, we are a long way from the hands-on interactives of the science centers. Nonetheless, the STS approaches of Shapin, Latour, Galison, and others, catalyzed through curators like Obrist, Vanderlinden, and Weibel, provide a new set of tools for bringing science into public, liberated from grand unified narratives and also from the need to focus on a pedagogical approach for young children and offering a plurality of potential interpretations. This is not a place where science is required to be "fun," or where science needs to be insulated from politics, but where science and politics are shown to be codependent and cocreated.

But in addition to ZKM, other "collider" spaces, residency programs, museums, galleries, and incubators have emerged to support new forms of science in public with varying approaches. How could these projects, generally coming from very different directions, inform the next generation of science museums?

SymbioticA
SymbioticA represented the first space worldwide to offer biological lab facilities, access to scientists, and funded residencies to artists.

It was founded in 2000 by artists Oron Catts and Ionat Zurr as a purpose-built "Art and Science Collaborative Studio" in the Department of Anatomy and Human Biology at the University of Western Australia in Perth, with input and support from university scientists including Dr. Miranda Grounds. Many artists who developed significant projects linking art and biology (Catts rejects the term "bioart") cut their biological teeth at SymbioticA. From Guy Ben-Ary and Phil Gamblen, to Boo Chapple, Paul Vanouse, Kira O'Reilly, and Orlan, SymbioticA has provided legions of bio-curious artists with access to the materials, tools, and processes of biology. One challenge for SymbioticA has been in finding the right places to show the works produced through their residencies, with Perth (proudly claiming to be "the most isolated city in the world") providing few opportunities for audience engagement—when they wanted to make an exhibition showing 10 years of SymbioticA creations, they had to do it right on the other side of the planet, as the exhibition *Visceral: The Living Art Experiment* at Dublin's Science Gallery.

The work produced through the SymbioticA program is distinctive for engaging with real biological materials, surrounded by laboratory paraphernalia. Catts and colleagues have been critical of the dream worlds of speculative design, preferring the idea of "contestable design," whereas some speculative designers have criticized some of the "semi-living" artworks emerging from programs like SymbioticA (but also characteristic of other artists working with living biological materials such as Austrian Thomas Feuerstein) as Gothic or even Frankensteinian. Rather than reject this tag, SymbioticA appears to have happily embraced its teratological reputation, with founder Oron Catts retracing the steps of the fictional Dr. Victor Frankenstein and author Mary Shelley, and having organized *Quite Frankly, a Monster Conference* to celebrate 200 years of the publication of *Frankenstein; Or the Modern Prometheus* in 2018.

Arts Catalyst
London's Arts Catalyst, founded by Nicola Triscott in 1994 and involving strong curatorial involvement of Rob La Frenais, has been a true pioneer as a highly ambitious commissioning organization supporting artists who are engaging with science. Projects of Arts Catalyst have included allowing artists and scientists to fly on magic carpets in zero gravity, and recreating bioterror experiments involving guinea pigs off the coast of Scotland. By bringing projects at the interface of art and science across the globe, into the air (through an artists' Air Show), onto the water, and even into space, the breadth of Arts Catalyst's projects and its deep commitment to supporting the ambitions of artists, wherever that might lead, arguably benefitted from lacking a dedicated venue—as soon as one has to run a physical venue, it is easy for even a highly creative team to become institutionalized and "think within the walls" of a building that is endlessly hungry for new content, another reason that more ephemeral formats (performances, festivals, pop-ups) have been presenting some of the most exciting "collisions." Since 2016, Arts Catalyst has its own dedicated space, the Arts Catalyst Centre for Arts, Science and Technology near King's Cross in London.[13]

Wellcome Trust and the invention of SciArt
Projects such as the ambitious commissions of Arts Catalyst did not occur in a vacuum (although they occasionally *did* occur in microgravity, and even, in the case of Simon Faithfull's *Escape Vehicle No. 6*, a chair lifted by a weather balloon into the upper atmosphere, in near-vacuum conditions). Instead they were enabled by a supportive funding environment, with the emergence of a particularly strong constellation of funders supporting transdisciplinary collaborations in the UK between funding initiatives such as the Interdisciplinary Arts Programme of the Arts

Council of England led by Tony White, the emergence of NESTA (the National Endowment for Science, Technology and the Arts) founded by film producer Lord David Puttnam, and the Calouste Gulbenkian Foundation supporting artists engaging with science.[14]

But arguably no funding organization has been more influential in shaping the art-science landscape in the UK than the Wellcome Trust, especially for art relating to biomedical science. Established with the bequest of the eclectic collector and inventor of tablet-based medicine Henry Wellcome, the founder of the pharmaceutical company Burroughs, Wellcome and Company that subsequently became part of what is now the global pharma giant GlaxoSmithKline, Wellcome Trust is now one of the world's largest charities, controlling assets of approximately £23 billion, currently giving away approximately £1 billion per year to fund biomedical research and public engagement.

In 1997, under Ken Arnold's leadership, the Wellcome Trust launched the funding program "SciArt," creating a new brand for art-science collaborations with a biomedical focus and visible public outputs. Arnold recognizes that "the SciArt funding initiative was unambiguously undertaken as a somewhat exotic branch of its general mission to engage the public."[15] An example of an early project funded under the SciArt stream was Marc Quinn's 2001 work *A Genomic Portrait*, representing Sir John Sulston, the former head of the Wellcome Trust Sanger Centre, and someone who had played a key role in the definition of the human genome. The portrait was exhibited in the National Portrait Gallery, accompanied by a more traditional photographic representation of the sitter.

While providing important financial support for many artists interested in science, SciArt came under some criticism for distorting the field by pulling artists away from other areas of science towards biomedicine, through the temptations of Wellcome

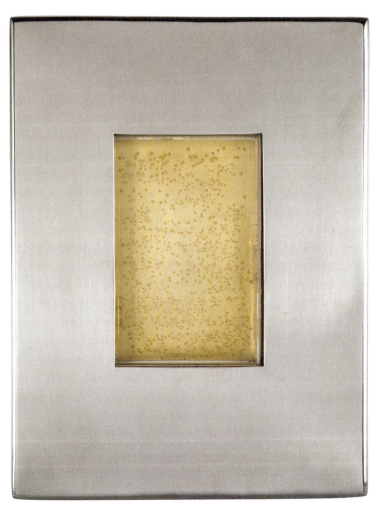

Marc Quinn, DNA portrait of Sir John Sulston, Nobel laureate, for his work on the sequencing of the human genome, commissioned by the National Portrait Gallery in 2001. *Source:* Copyright and courtesy of Marc Quinn Studio.

Trust support, and for the impression that art was in some way being instrumentalized, as an instrument to communicate the importance of medical research, rather than as an agent of societal change in its own right. Some artists also worried that being tagged with the SciArt label might ultimately ghettoize them, and isolate them from the rest of the art world.[16]

In 2006 the SciArt program ended, shortly before Wellcome Trust opened its impressive new Euston Road museum, Wellcome Collection, in 2007, to show Henry Wellcome's highly eclectic collection of artworks and objects connected to health and medicine, and contemporary artworks linking with current biomedical science, and also to feature changing self-generated exhibitions on broad themes such as the heart, or skin, bringing medicine, art, and cultural history into creative dialogue. As Arnold notes, "vibrant and illuminating versions of these connections are especially likely in medical contexts, where sometimes intensely personal feelings bring new meaning to insights from biomedical laboratories and statistical analyses." The process of shared investigation and experimentation by scientists and artists is often as important as the end result, and Arnold recognizes that some of the strongest interdisciplinary projects make that (often playful) process visible.[17]

Wellcome Collection also experimented with different types of residency programs, interacting with the public galleries, culminating in the recent creation of The Hub, a collective residency program where transdisciplinary teams compete to receive a £1M funded residency over two years, involving scientists and artists in developing ambitious projects on themes such as dementia. They are provided with a dedicated collaboration space perched at the top of the Wellcome Collection to allow for extended investigation of a topic, punctuated by public interventions.

Arts at CERN

What could be a more appropriate location for cultural collisions between art and science than the site of the Large Hadron Collider in CERN? When Ariane Koek persuaded CERN to host an arts program, harnessing the clear fascination of many artists for the underground headquarters of the world's largest experiment, in contrast to Arnold's goals for SciArt and Wellcome Collection, it was important to her that no public output would be required, and that the artists be as insulated as possible from CERN's significant public relations machinery. Then-director of CERN Rolf-Dieter Heuer had more instrumentalist goals for the program: "We have to show society what we are worth and what we are doing for society. To transmit that through art, partially at least, in my mind is important and it opens horizons."[18] Many artists had already visited CERN spontaneously prior to the existence of the program, from sculptor Antony Gormley to musician Björk, and British filmmaker Ken McMullen had initiated the project "Signatures of the Invisible" in 2000, leading to the film project *Art, Poetry and Particle Physics* (2004) with writer John Berger. While artists participating in the "Collide" residency did not have to produce any output, some did, including Julius von Bismarck, who kidnapped thirty CERN scientists, seekers of invisible particles, and held them hostage underground in pitch darkness, while interrogating them about what they saw in their minds' eye—perhaps a gesture of resignation to the futility of the shared quest of both artists and scientists to make the invisible visible.[19]

Le Laboratoire: Art-Science as Innovation

Also in 2007, the same year as the opening of Wellcome Collection in London, a new art-science incubator space, Le Laboratoire, opened its doors in Paris. Le Laboratoire founder David Edwards is a Harvard professor of biomedical engineering and entrepreneur

who had developed a new approach to allow diabetics to inhale, rather than inject, insulin, as founder of the company Advanced Inhalation Research (AIR) which was sold to biotech company Alkermes for about $106 million, who then partnered with Eli Lilly to commercialize the technology. While Eli Lilly ultimately dropped the technology when it failed to gain market traction, the lucrative sale allowed Edwards to privately fund the creation of an ambitious art-science laboratory at a prestigious location next to the Palais-Royal in Paris.

With Edwards's provenance from the biomedical innovation scene of Cambridge, Massachusetts, Le Laboratoire had a strongly entrepreneurial approach, with a focus on value creation and IP generation through a series of "experiments" involving cooperations between artists and scientists. While some of the "outputs" of Le Laboratoire were commercial products, like "Andrea," a plant air-filtering system created by Edwards with talented product designer Matthieu Lehanneur, or the "breathable chocolate" device Le Whif, later rebranded Aeroshot, it would be a mistake to suggest that Edwards was exclusively focused on commercial innovation. The vision of Le Laboratoire, and also the related ArtScience Prize and Idea Translation Lab undergraduate course established by Edwards at Harvard, also aimed to stimulate cultural, educational, and social/humanitarian entrepreneurship. While Le Laboratoire hosted events and exhibitions to display and test the results of art-science experiments, this was not a "museum" in any sense of the word, but a space of transdisciplinary creation, where the visiting "public" was of secondary concern to the innovation process. Generally the experiments of Le Laboratoire involved an artist and scientist being invited to collaborate, with the idea that the result could be an artwork, or a new social project, or possibly an idea for a new commercial product. Examples included the collaboration between composer and digital artist Ryoji Ikeda and mathematician

Dick Gross to create a "silent composition" displaying the seven million digits of one of the longest known prime numbers and the first seven million digits of a much larger random number on two horizontal slabs, clearly a project without significant potential for commercialization.

Le Laboratoire also founded its own venture capital arm, the Labo Group, to invest in promising projects emerging from ArtScience experiments. The street-facing shop window of Le Laboratoire allowed passers-by to peer into the "brain room" where Edwards and colleagues could be seen sketching ideas for new designs on a giant curved whiteboard, or sitting in contemplation on geodesic beanbags. The mythology of Le Laboratoire and its inventions was immortalized in a series of novels and manga comics, sometimes with Edwards as protagonist, including *Niche* and *Whiff*.

Le Laboratoire, the Wonka chocolate factory of the artscience world, then relocated to Kendall Square in Cambridge, Massachusetts, far away from the worlds of art and fashion that swirled around its Parisian incarnation, but recently closed its doors to undergo yet another metamorphosis.

MoMA and Paola Antonelli: Design and Science

New York's Museum of Modern Art had witnessed some of the explosive transdisciplinary experiments of Billy Klüver and Swiss kinetic sculptor Jean Tinguely back in the 1960s. In 2008, MoMA design curator Paola Antonelli opened her landmark exhibition *Design and the Elastic Mind*, an expansive exhibition incorporating the work of young and emerging designers bringing design and science together in unexpected ways, and bringing a global audience to experience work at the bleeding edge of speculative and critical design. Since then Antonelli has developed a series of important exhibitions, online projects, and salons, and founded the MoMA R&D Lab, transforming MoMA into a vital platform

for discussions of the intersection between design and emerging science and technology, connecting back to Alfred Barr's founding vision of MoMA as museum-as-laboratory in whose experiments "the public is invited to participate."[20]

In launching *Design and the Elastic Mind*, Antonelli proclaimed a "brand new love affair" between designers and scientists, focused around the opportunities for bottom-up construction offered by nanotechnology, tissue engineering, and synthetic biology. Designers and scientists, according to Antonelli, now "seek each other out," as they need each other to realize their ambitions.[21]

By embedding a hotbed of critical and speculative design within an established cultural institution like MoMA, Antonelli has recast design as an instrument for engaging with urgent societal concerns through "upstream engagement" with emerging science and technology.

One could easily provide many more examples of the new cultural institutions emerging (and sometimes just as quickly disappearing) around the globe in the Age of Entanglement—from the highly experimental Kapelica Gallery in Slovenia to the recently closed Machine Project in Los Angeles, from the Ectopia residency program of Marta de Menezes in Portugal to the ArtScience Museum in Singapore, from RIXC in Latvia to Laboratoria in Moscow to CCCB in Barcelona. The list goes on and on.

The collisions of science with art and design are not without their critics. *Guardian* art critic Jonathan Jones attacked Ryoji Ikeda's installation *Supersymmetry*, created as the result of his experiences at CERN, asking "isn't it time we stopped expecting artists to understand the complexities of science?" and denigrating the work as "intellectually and emotionally empty art."[22] Of all the artists one might accuse of a superficial engagement with science, Ikeda, who has had extensive engagement with mathematicians and scientists throughout his career, seems like a peculiar target

for Jones's ire. Science writer Simon Singh has also attacked the spending of large sums of money on science-art projects, citing a ballet about Einstein ("People hate physics, they hate ballet; all you've done is allowed people to hate things more efficiently") and a "palace" made of children's milk teeth which was apparently intended to "teach people about stem cells," claiming that the best science communication activities and events were often "dirt cheap"—such as gatherings of skeptics in pubs or mathematically-themed YouTube videos.[23]

While there is undoubtedly a great deal of mediocre work that has emerged from art-science collaborations, such criticisms often make the erroneous assumption that the goal of an art-science project is to explain scientific concepts to the public, rather than, say, to create a new artwork or even a new medical device.

Why is it, though, that the idea of art engaging with science tends to face more such attacks than art engaging with, for example, politics or religion? Art designed to communicate politics or religion would be dismissed immediately as worthless propaganda, but why do critics such as Jones or Singh still yearn for an artist like Ikeda to be an efficient mechanism to communicate particle physics?

The myriad hybrid institutions emerging in the first decades of the twenty-first century to connect science, art, design, and technology in new ways often have quite different missions from traditional science centers and museums. Rather than aiming simply to inform the public about science, they are often sites for the creation of new knowledge at the interstices of traditional disciplines, new artistic projects, new design provocations, and even new products, places of experimentation, connection, and critical discussion.

4

Safe Sex in the Academic Realm: The Science Gallery Experiment

> A visit to the Science Gallery is enough to give one hope about our future. Scientists are reaching out to designers, artists, and writers not to perform empty vanity exercises, but rather to create solid, interdisciplinary teams that can cover all the scales and facets of nature. Together they engage in responsible tinkering, the equivalent of safe sex in the academic realm. And they prove that science not only has a heart, but also a sense of humour.
> —Paola Antonelli, Senior Curator, Design and Architecture, MoMA, New York

On a cold, dark evening in February 2008, commuter traffic clogged up Pearse Street, one of the busiest arteries in Dublin's city center. Alongside the traffic jam, a quadricycle driven by a strange group of alien-like figures wearing pulsating LED spheres on their heads was maneuvering into place outside a new glass-fronted building, and a crowd was making its way inside the building, a transparent frontage of Trinity College Dublin onto the city. It was the opening night of *Lightwave*, the festival exploring light in art, science, and technology, launching Dublin's Science Gallery.

Inside the building, scientists, artists, and designers were involved in animated conversations, and visitors were participating in LED graffiti workshops and experimenting with electroluminescent fibers and fabrics. Up the large open staircase, past a 3-D visualization of solar flares by Trinity College astrophysicist Peter Gallagher, was a queue of Dubliners waiting patiently. Evelina Domnitch, a Belarusian artist-scientist with a swirling pattern shaved on her cranium, invited small groups of visitors into a mysterious dark chamber.

They waited in silence for almost ten minutes for their eyes to grow accustomed to the darkness and then a rising tone began to emanate from a liquid-filled transparent sphere. When the sound reached a certain pitch, startling luminous streaks began to

Opening night of Science Gallery and the *Lightwave* festival, February 2008.
Source: © Science Gallery, Trinity College Dublin.

penetrate the liquid, forming changing three-dimensional patterns of light—displaying the phenomenon of sonoluminescence, sound becoming light, as tiny bubbles formed in the liquid are made to implode and reach temperatures that, according to some, are as hot as the surface of the sun.

Stepping out of the darkness, a group of students, arty types, and a couple of elderly local women were crammed into the point of the building where they were staring into a large cubical arena, in which live bumblebees navigated towards colored lights to find a sugar reward. An experiment was in progress on the color vision of bees and their ability to learn to associate particular shades with sugar. The bees' flight paths had been scanned in three dimensions and laser-etched onto resin blocks which were stacked into glowing towers of blocks tracing the learning curve of the female bumblebee. Neuroscientist Beau Lotto was patiently explaining the principles

of the experiment to the group when suddenly a bumblebee managed to escape from the arena and staff and students alike gleefully chased her (because it was always a female) around the building. In the meantime, a DJ had started up downstairs, and a dancer wearing a fluorescent dress was weaving her body, her movements mirrored by a light-tracing installation.

Lightwave was intended to be a one-week festival, to be followed by an exhibition about the human face, but disaster struck when the curator of the latter exhibition pulled out at the last minute, due to concerns about the gallery's climate control conditions, leaving a gaping hole in the calendar.

We racked our brains to come up with a replacement show that could be developed at ultra-short notice. I had been impressed by the work of artist Susie Freeman and medical doctor Liz Lee

Beau Lotto, *Bee Cube*, an experiment on bumblebee vision and learning, at the *Lightwave* festival, Science Gallery, 2008. Source: © Science Gallery, Trinity College Dublin.

(together known as Pharmacopoeia) incorporating pills in textiles—including their piece *Jubilee*, a wedding dress incorporating a lifetime average consumption of 6,279 contraceptive pills in colored foil wrappers, and their *Cradle to Grave* installation at the British Museum with all the pills that a man and a woman would consume in their lifetime laid out on fabric as "life tapestries."

We phoned Susie Freeman, and inquired about her potential interest in an exhibition of her work in Dublin. When we then said it had to open in less than three weeks, she laughed. She wasn't laughing any more when just a few days later, we sent a van to London to pick up almost the entire collected works of Pharmacopoeia. Talented designer Gerard O'Carroll came up with the idea of making the exhibition feel like a distorted version of your grandparents' house, where pills are often encountered, by buying second-hand furniture—dressers, cabinets, sideboards—and painting it all a uniform mid-grey, to allow the vibrant colors of the pills to pop out.

It was publicly announced that *Lightwave* was being extended "due to popular demand" until the end of February, to buy some time, and then, on March 15, 2008, we opened our second Science Gallery exhibition, *PILLS: Which Ones Have You Taken?*

The timing was uncanny, as just as we filled the gallery with the delicate pill-based textile works of Pharmacopoeia, the debate about whether or not antidepressants worked was exploding in the media, following the publication of Irving Kirsch's study that antidepressants had no greater effect than placebo in the majority of patients.

We immediately invited Kirsch to Dublin for a heated debate on the benefits or otherwise of antidepressants with prominent Irish psychiatrist Dr. Veronica O'Keane, with the backdrop of Susie Freeman's pill installations. We experienced our first Science Gallery "fake news" story when it was reported in an Irish tabloid

newspaper that "junkies" from the methadone clinic located across the road from Science Gallery had stolen psychoactive pills from our exhibition, crediting an anonymous source within Trinity College.[1]

Ireland was especially hard hit by the 2008 financial crash, creating an atmosphere of austerity, and placing gallery funding on a somewhat precarious footing in its opening years. Nonetheless, the public was fascinated by this strange new addition to Dublin's cultural scene. Expectations of 50,000 visitors per year were quickly smashed with over 120,000 visitors in 2008, and doubling this to 245,000 visitors in 2009. The small gallery which replaced a car park at the back of Trinity College now regularly receives over 400,000 visitors per year, making it one of the top ten free visitor attractions in Ireland, despite being a fraction of the size of the others, with a high proportion of over 40 percent repeat visitors, due a rapidly changing program and a free entry policy.

Science Gallery had its early origins in the goal of scientists (and science funders) to demonstrate the value of their research to the public.

In 2003, the Irish government founded Science Foundation Ireland (SFI), strongly inspired by the US National Science Foundation, with the goal of supporting "oriented basic research" in "information and communication technologies (ICT)," "biotechnology," and "such other areas that concern economic and social benefit, long-term industrial competitiveness or environmentally sustainable development."[2]

William Harris, the first director general of SFI, was an NSF veteran, and one important funding mechanism he established for SFI was a call for new so-called CSETs, or centers for science, engineering, and technology.

A group of physicists and chemists in Trinity College, including Atomic Force Microscope pioneer John Pethica, nanomagnetics

expert Mike Coey, and graphene chemist John Boland, developed an ambitious proposal for a new CSET for nanoscience (at the peak of the nano hype-cycle in the mid-2000s), calling it CRANN, the Centre for Research in Adaptive Nanosystems and Nanodevices. Unlike some of the other planned CSETs that were to be virtual cooperations between existing universities, CRANN would be a physical center, requiring a new high-tech building in central Dublin to house delicate nanoscience research experiments. A construction site was identified on a car park behind some railway arches at the rear of the "science end" of the Trinity College campus, literally on the wrong side of the tracks. The new center would involve deep collaborations with industry, with embedded researchers from Intel and HP, from the first generation of tech multinationals to house major facilities in Ireland, before being joined by Microsoft, Google, Facebook, Twitter, LinkedIn, and many others in enjoying the unique dividends of the peculiar Irish tax situation.

As in the United States, Irish CSETs were expected alongside their research proposal to articulate their plans for "education and outreach," to demonstrate to the public the positive impact of research. Often these involved school projects and activities of a designated "outreach officer," usually a more junior scientist who was transitioning away from a research career.

At Coey's original suggestion, CRANN incorporated in its proposal a more ambitious vision of science outreach, through the creation of a purpose-built, 1,500 square meter space, a "science gallery." Availing of Trinity's city-center location, the new two-story gallery, sandwiched between the labs of the nanoscience research institute, would allow the public to be informed about the importance and value of scientific research in a welcoming setting.

Nanoscience was particularly alert to the need for good public relations. After Prince Charles had raised concerns publicly in the

UK about nanotechnology triggering the "grey goo" scenario, the Royal Society was forced to write a report to allay such concerns. An otherwise sober document described the following apocalyptic scenario:

> Hopes have been expressed for the development and use of mechanical nano-machines which would be capable of producing materials (and themselves) atom by-atom. . . . Alongside such hopes for self-replicating machines, fears have been raised about the potential for these (as yet unrealised) machines to go out of control, produce unlimited copies of themselves, and consume all available material on the planet in the process (the so called "grey goo" scenario).

It was strongly feared by scientists in the UK and elsewhere that the lack of good public communications around the great societal benefits of nanoscience and nanotechnology would risk nanoscience being beset by the issues surrounding genetically modified organisms. Books like Michael Crichton's science fiction novel *Prey*, with swarms of self-replicating nanorobots causing havoc and destruction, certainly didn't help matters, and there were semi-naked protests by a group called Thong (Topless Humans Organized for Natural Genetics) outside a Chicago clothing store against the use of nanotech in a pair of stain-proof trousers. Less peacefully, in Mexico, nanotechnology facilities were soon afterwards even targeted with bomb attacks by protestors, exactly when swarms of materials scientists, chemists, and atomic physicists were racing to rebrand themselves as nanoscientists to fit strategic government funding calls around the world. In this global context of fear and hype, public engagement with nanotechnology could be critically important.[3]

Science Gallery was originally somewhat traditionally conceived, and intended to be a key instrument to inform the public about the value of scientific research in general and nanoscience in particular. The building itself would reflect this. The walls were to

be decorated with James Clerk Maxwell's fundamental equations of electromagnetism, and the floors would be patterned with aperiodic Penrose tiling.

Science Gallery was, when first instigated, a science-driven project intended as a textbook example of "deficit model" science communication. The Irish public was, it was believed, by and large ignorant about science, and needed to be informed—much like teacher Thomas Gradgrind's "little pitchers ... who were to be filled so full of facts" in Dickens's *Hard Times*—so that they could reap the benefits of greater science literacy and realize the enormous value of the investment the Irish government was placing in science. Additionally, more students needed to be attracted into STEM courses and careers to fuel Ireland's "knowledge economy," and it was hoped that Science Gallery could create a public face for science subjects that would attract prospective students into science.

In spite of this approach, even at the embryonic stages, Science Gallery had some features which would remain important as the project came to life, albeit in a quite different form than originally anticipated.

First, unlike many existing science museums and science centers, it was a strong principle that the gallery should not be aimed primarily at children, but instead target young adults and adults with its programs. The focus on an adult audience was assisted by the fact that plans also existed for a large children's science center, the "Exploration Station," inspired by the Boston Children's Museum, under the patronage of designer Ali Hewson, wife of U2 front man Bono. By targeting adults, Science Gallery would complement rather than duplicate the younger audience demographic of Exploration Station, a project that was stalled by the Irish property crash and still remains unrealized more than ten years later, though from time to time its ever-imminent opening is announced in the press.

Second, in keeping with the goals of Science Foundation Ireland, Science Gallery would focus not on well-established science or on basic principles, but on current research, including but not limited to nanoscience research. The focus on current research implied a level of flexibility of content, and close cooperation with research scientists, including those of the "parent" university, Trinity College Dublin.

As a model of how to present current research to a lay audience, Coey and his colleagues looked for inspiration and advice to the (now closed) Marion Koshland Science Museum in Washington, DC, which was set up as a public outreach arm of the US National Academy of Science. The exhibits included rather dense, information-rich, on-screen and wall displays about topics such as climate change or safe drinking water. All exhibit texts were subjected to rigorous vetting for scientific accuracy by NAS scientists.

Rethinking Science Gallery

In January 2017, almost exactly one year before the gallery was due to open, I was hired by Trinity College for the role of founding director of Science Gallery. The construction project had already begun, with a tight timeline due to the coordination with the research labs, and there was a big task ahead, with a significant fundraising challenge and a need to define a (new) vision for the gallery, fit out the space, build a team and a program of events and exhibitions, all at breakneck speed.

In my job interview for the Science Gallery role, I had proposed that if the gallery wanted to succeed, it needed to embody three simple words: *connect*, providing opportunities for new kinds of social connections between different communities; *participate*, offering opportunities not for "interactivity" in the science center

sense, but for genuine involvement of visitors in creating the experiences; and *surprise*, capturing the imagination of visitors and the media with genuine surprises on an ongoing basis.

I was not in any way a "museum person," and this probably gave me a different approach to the challenge of realizing Science Gallery than someone better versed in museums might have adopted. Instead, I came from an academic background in history of science and Science, Technology and Society (STS), which I had taught at Stanford University. As well as having grown up with the writings of Shapin, Schaffer, and Latour in relation to understanding science in action, I had developed a strong interest in the interplay of art, science, design, and technology, through working on Buckminster Fuller's designs and encountering artists like Ruth Asawa and Kenneth Snelson who had been part of the transdisciplinary environment of Black Mountain College, and also through developing "extracurricular" exhibition projects such as *Machinations: The Art of the Machine* featuring the work of San Francisco machine artist Bernie Lubell.

I had returned to Dublin from California lured by the opportunity to create and lead a new center for art, science, and technology for teenagers, Arkimedia, in cooperation with The Ark, a pioneering children's cultural center. I had developed the vision and written the business plan for Arkimedia, which was due to be realized in a high-profile building in Dublin's Temple Bar area when the person who had hired me was suddenly ousted by his Board of Directors, and I found myself afloat in Dublin, having resigned from my position at Stanford.

While the Arkimedia project was abandoned, I did have the opportunity to realize one major, citywide curatorial project with The Ark, originally intended to be the launching program of Arkimedia, called *Save the Robots*, which explored the relationship between robots and art, from Heron of Alexandria's automaton theater to the

feral robot dogs sniffing out toxic chemicals of Natalie Jeremijenko, to the robot artist and DJ projects of RobotLab, and "Dirk," a robotic tramp who pushed a shopping trolley around Dublin, stretching out his hand to beg for money from passing pedestrians.

One of the many diverse elements of *Save the Robots* was ArtBots, the robot talent show, originally conceived by Columbia University–based artist Douglas Repetto, which took place in a converted church, creating a wonderful setting for robotic art and art-making robots. As co-curator of the Dublin ArtBots with Repetto and computer scientist Marie Redmond, I received a thorough schooling in the noble art of the open call, later to become a key aspect of Science Gallery exhibitions and programs as a key "feeder" into the Idea Collider described in chapter 1.

While Arkimedia was never realized and the business plan was shelved, like many failures the project provided some extremely valuable learnings about how to create opportunities for serendipitous collisions between science, art, and technology for teenagers and young adults that fed directly into the development of Science Gallery, and also provided the invaluable education of what is commonly referred to in Ireland as the "school of hard knocks" in relation to the multiple challenges involved in realizing ambitious public cultural projects.

Another initiative that fed into the thinking around Science Gallery was SEED art-science projects, a nonprofit organization that I cofounded with foam physicist Wiebke Drenkhan and a group of Dublin artists, designers, and scientists, including Raymond Keane of theater group Barabbas, visual artist Sean Hillen, poet and physicist Iggy McGovern, graphic designer Ciaran O'Gaora, and author Mary Mulvihill. SEED organized art-science salons involving experimental events at the Odessa Club in Dublin, co-owned by artist and SEED member Peter O'Kennedy, including SEED-dating events where artists and scientists would speed-date

to spark off new collaborations. Many of the people originally involved in SEED also became involved in Science Gallery.

From Science on Top to Science on Tap

In keeping with its research lab setting, Science Gallery was due to open with an 18-month exhibition demonstrating the potential of nanoscience to revolutionize all sorts of different fields of human endeavor, from energy and computing to warfare and medicine, which was in development with a UK-based exhibition design company on my arrival.

One of the physicist-instigators of Science Gallery had advocated in a paper to the Gallery Board that "all Gallery events should respond to the questions, 'What significant scientific information is this event intended to convey' or 'How does it serve to promote science.'" It was also requested that "A Scientific Advisory Panel should be established by the Board, comprising about six experienced scientists from Trinity College Dublin and elsewhere i) to review material ... for scientific accuracy and ii) to advise the Director on the programme."

To transform Science Gallery into a place of connection, participation, and surprise, it seemed that a radically different approach was required.

Working with a tiny team initially of three full-time people (growing to four by the opening), we quickly scrapped the dismal nanoscience exhibition and the whole idea of the scientific advisory panel, and instead created a group called the Leonardo Group, a volunteer "brain trust" consisting of up to fifty scientists, artists, engineers, designers, and other creative people whose expertise we could draw on freely to inspire Science Gallery programs and exhibitions and to identify themes. In addition to this creative group, a Science Gallery Governance Board was established,

including entrepreneurs and university academics to oversee the gallery's activity, chaired by entrepreneur and Iona Technologies cofounder Chris Horn.

We proposed the idea that, rather than a place to "inform" the public, Science Gallery should be a sociable "meeting place for ideas"—where science would be brought into "creative collisions" with other areas of culture, from fashion and music to art.

After a challenging first year, with some important learnings, the gallery programming settled down somewhat into a more manageable (though always fast-paced) rhythm, especially as new team members joined. However, the architecture of spontaneity and ability to reconfigure quickly and to maneuver around obstacles remained an important element of the gallery's energy and ethos.

Overcoming Skepticism

Initially, the gallery's approach—shifting from a top-down process of science communication and science promotion, to science as part of a curious and creative conversation among equals around broad themes of societal concern—was met with a good deal of skepticism from some university scientists who considered the gallery's approach too superficial or not sufficiently didactic, and were uncomfortable about the collisions of ideas from science and other areas of culture—art, design, fashion, music.

The strong support of John Hegarty, then Trinity College provost and a physicist who had previously worked in Bell Labs, that melting pot of transdisciplinary creativity, and the entrepreneurial Science Gallery chairman Chris Horn helped to create the air cover to allow the Science Gallery experiment to proceed in spite of the complaints of some nanoscientists.

An important step in achieving greater credibility with the scientists for this new vision occurred when the Wellcome Trust

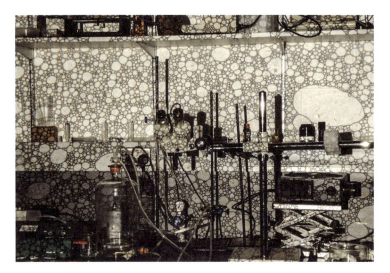

Foam Lab at Science Gallery for the *Bubble* exhibition, 2009. *Source:* © Science Gallery, Trinity College Dublin.

came on board a short time before the gallery opening as a key funder of the gallery, providing £1 million to support fit out of the building and biomedically themed exhibitions, and endorsing the gallery's new vision of bringing science, art, and culture into creative dialogue (they had rejected a previous proposal based on the old concept).

Also important were some early successes for Trinity scientists—eminent physicist Denis Weaire, whose Weaire-Phelan Structure, a minimal energy structure for foams, inspired the design of the Beijing Aquatic Centre and the artist Tomás Saraceno's Cloud City on the roof of the Metropolitan Museum in New York, became involved early on in the Science Gallery exhibition *Bubble*, along with his colleagues from the foam physics group. The experience of having over 60,000 people visit an exhibition featuring their research and bringing foam physics into collision with art through the work of Tim Durham and Michael Boran was exhilarating.

Professor Luke O'Neill, a leading immunologist who co-curated *Infectious* with fellow immunologist Cliona O'Farrelly, became an outspoken champion for the gallery's approach. Regular features on the gallery's events on the national television news, featuring Trinity College scientists, and articles in journals including *Nature* and *Science* also helped win over the skeptics. Gradually, most of the internal critics fell silent, and in some cases even began approaching the gallery team with ideas for future exhibitions scrawled on the backs of envelopes.

Lab in the Gallery: Science in the Making

If one really wanted to connect the public with "science in the making," as Shapin proposed, what about conducting real research in a public space and harnessing the gallery visitors as volunteer participants in human subjects experiments? Neuroscientist Ian Robertson proposed to relocate his lab to Science Gallery to conduct experiments on attention. Dublin Theatre Festival director Loughlin Deegan was interested in the idea of the research lab becoming a public spectacle, and so the Lab in the Gallery format was born as part of the program of the Dublin Theatre Festival. Contemporary research laboratories were not very theatrical, however, with no gothic glassware and little in the way of performance. The real success of Lab in the Gallery was not as a theatrical experience, but in attracting visitors to participate in real research experiments in a public space, which led the scientists involved to acquire quantities of experimental data which would have otherwise taken years. For the public, this presented a unique opportunity to talk in person with a neuroscientist about the workings of the brain, and to contribute to research. This format worked especially well for areas of research requiring human subjects, such as genetics, psychology, and neuroscience. *Love Lab*, a later example of Lab in the Gallery,

included an experiment on speed-dating, leading to a major peer-reviewed publication in the *Journal of Neuroscience* on the science of romantic rejection.[4] Science Gallery's Lab in the Gallery program also brought scientists on board, in part through enlightened self-interest in gathering valuable experimental data, and required the gallery ultimately to create its own Ethics Committee.

One Science Gallery exhibition, *Biorhythm: Music and the Body*, included a touring research experiment exploring people's physiological responses to different music samples, entitled *Emotion in Motion*. An interesting feature of this experiment was that as it toured globally with the exhibition, from Dublin to New York, from Taiwan to Singapore, it gathered data from participants in each location, providing researchers with the opportunity to compare physiological responses to music in different locales. In *Biorhythm*, this research experiment was situated alongside more light-hearted

Experiment on smell of the pheromone androstenone as part of *Love Lab* at Science Gallery, 2010. *Source:* © Science Gallery, Trinity College Dublin.

Joan Healy, *My Hairy Banjo*, at *Biorhythm: Music and the Body*, 2010. *Source*: © Science Gallery, Trinity College Dublin.

projects such as Joan Healy's performative artwork *My Hairy Banjo*, where the artist, hidden from view behind the "instrument," allowed her own hair to be plucked to play a musical instrument.

Constraints

Like many creative projects, Science Gallery began with a number of constraints which helped to shape its character.

First, scale. Science Gallery was a small, awkwardly shaped, two-story space, which excluded the possibility of creating a large, destination science center, encouraging a focus on making the gallery a meeting place.

Second, Science Gallery had no permanent collection, making it impossible for it to fall back on a permanent exhibition, and requiring a rapid pace of change.

Third, Science Gallery could not rely on receiving significant government or university funding, especially after the economic crash of 2008 which occurred just after its opening, so it was forced to be hungry and seek partnerships from foundations and technology companies to realize its vision.

Fourth, the gallery was constrained by its target audience of young adults and adults, requiring a different approach to exhibitions and events than science centers, but also allowing some content to be presented which would be taboo in children's science centers.

Fifth, the planned use of open calls for exhibition generation meant that exhibitions could not be expected to adopt a traditional linear narrative structure, but were instead dynamic and surprising assemblages of ideas and projects.

A Place for Conversation

It was an important goal of the founding team that Science Gallery would be no silent and reverential white cube gallery space, but a place of engaging conversations across boundaries, harking back to the seventeenth-century coffeehouses as places of vibrant exchange between science and culture. As the original building plans had included no café, but merely a tea station for employees, an urgent task was to adapt the plans to accommodate a café, knocking a hole in a wall and transforming a "lecturer's preparation area and workshop" behind the theater into a food preparation area. The Science Gallery café became the beating heart of the gallery, drawing repeat visitors, and being a place of informal events and activities. When we did an exhibition on the theme of water, *Surface Tension*, the café had a water menu, showing the water footprint of each food choice.[5]

Perhaps even more important than the café in making Science Gallery a place for conversation were the "mediators." These were

generally university students, from the sciences or sometimes engineering or humanities, who would engage visitors (who so wished) in conversations stimulated by the artworks and other objects on show.

As a goal of the gallery was to attract 15 to 25 year olds (normally not to be found spending time in science centers and museums) into engaging with themes connecting emerging science and technology with culture, having mediators who were peers of the visitors engage in passionate discussion proved a highly successful approach. In every visitor survey, conversations with the mediators were rated as a highlight of a visit to Science Gallery. The visitor book contained many positive and sometimes amusing comments in relation to the mediators, such as "the mediators are hot!"

Works like *Victimless Leather*, a diminutive semi-living jacket created by Oron Catts and Ionat Zurr and exhibited in the 2008 exhibition *TechnoThreads*, became springboards for conversations with mediators traversing ethics, biology, and design. Would you feel comfortable wearing a living jacket grown from mouse stem cells? Would it be more ethical to wear tissue-engineered human skin, as the donor could give consent? When a version of the jacket growing at exactly the same time at MoMA in New York had to be euthanized by curator Paola Antonelli, leading to headlines like "Museum Kills Live Exhibit," this sparked more conversations and admittedly a certain amount of *schadenfreude* from the Dublin curatorial team, lasting until our own tiny jacket caught an unpleasant fungal infection.[6]

While standing by *The Vision Splendid,* an artwork in the *Visceral* exhibition created by Alicia King from a living cell line of a 13-year-old African-American girl who died in 1969, one might be prompted to discuss who really owns and controls our cells, and how we feel to be able to order such cell lines directly over the internet.

Tissue Culture & Art Project (Oron Catts and Ionat Zurr), *Victimless Leather*—a "semi-living jacket" created from human and mouse stem cells, shown in *Techno-Threads* at Science Gallery Dublin. *Source:* The Tissue Culture & Art Project (Oron Catts and Ionat Zurr), hosted by SymbioticA, The University of Western Australia.

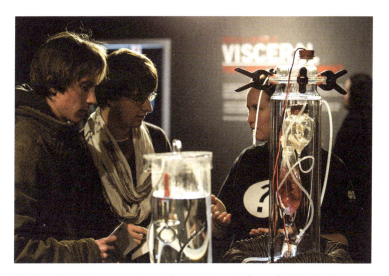

Mediator (right) in conversation with two visitors, in front of Alicia King's artwork, *The Vision Splendid*, created using a commercially available cell line isolated from a 13-year-old African-American girl in 1969. *Source:* © Science Gallery, Trinity College Dublin.

The mediators themselves benefitted from the experience by developing their communication skills, leading many of the "alumni" of the mediator program to go on to do remarkable things—developing science-related radio shows, becoming TV stars, or starting their own science-art projects.

Even the mediators who did not emerge as national media personalities reported that their experience in Science Gallery had a positive effect on the way they communicated about their work.[7]

A third very important form of conversation was the chance to converse with the artists and scientists themselves. Because Science Gallery shows were primarily developed through open calls with a bit of gap-filling through invited projects, the people selected to participate were generally very enthusiastic to be present at openings, events, and gallery talks, and to discuss their experiments,

rather than simply shipping a crated artwork, as could be the case if one worked with a more closed curatorial process and more established or mainstream artists.

This meant that visiting and local scientists, artists, and designers were constantly milling around the gallery, and often available for a chat, either in relation to their own project or installation, or through specially designed formats like "meeting of minds" table-dating events in the Science Gallery café.

Ken Arnold has suggested that "interdisciplinary collisions are most evocatively and meaningfully encountered by looking at things in public galleries." Science Gallery, on the other hand, somewhat like the seventeenth-century cabinets of curiosity, takes a more triadic approach, where the "things" on show in the gallery were not simply objects in their own right but stimuli to conversations about matters of concern, conversations which could go in many directions.

Because its projects were presented as experiments, and because they were generally not on show for very long, Science Gallery was sometimes able to take risks that might have been difficult for other gallery spaces, and tolerate a certain degree of messiness. One Science Gallery exhibition, *Fail Better*, inspired by Samuel Beckett's *Worstward Ho* ("Ever tried, ever failed? No matter. Try again, fail again, fail better."), celebrated the idea of instructive failure through examples selected by figures from many different fields, from architecture to space exploration. On the opening night of the exhibition, a glass vial of radioactive moonshine distilled illegally by babushkas in the Chernobyl exclusion zone was accidentally dropped on the floor, smashing in tiny pieces and releasing the mildly radioactive contents.

During another exhibition, *Oscillator*, Australian artist Helen Pynor reanimated two pig hearts, fresh from the local abattoir, which proceeded to pump blood for almost an hour through an

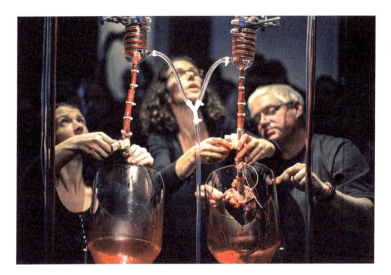

Artist Helen Pynor reanimates a heart in her work, *The Body Is a Big Place*, at the launch of Oscillator at Science Gallery, 2013. *Source:* © Science Gallery, Trinity College Dublin.

elaborate piece of glassware in front of a mesmerized audience, as part of her work *The Body Is a Big Place* in collaboration with cardiac physiologist Mike Shattuck.

Conversations exploring possible futures and ethical dilemmas, inspired by provocative and sometimes risky installations, became a central feature of the Science Gallery approach.

Futures on Display

Rather than presenting the well-established results of science in an accessible form, Science Gallery was interested in working with scientists, artists, and designers to explore possible futures. The speculative design work being carried out by Tony Dunne and Fiona Raby and their Design Interactions students at the Royal College of Art in London represented an especially rich seam of work to draw

people into conversations about how developments in science might permit alternative futures, leading to the exhibition *What If . . .* , which provided provocations around the future through a series of "what if" questions: What if meat could be grown in laboratories without harming animals? What if we could use smell to find the perfect partner? What if we could redesign human teeth to encourage vegetarianism?

Perhaps surprisingly, given the risqué and dystopian nature of some of the designs included in *What If . . .* , the exhibition proved a huge hit with school groups (a group which we had deliberately not courted with science gallery programs at the beginning, to avoid developing the reputation of being a place where you were dragged by your teacher). Contrary to our expectations that teachers would be drawn to more curriculum-based exhibitions, it seemed that some teachers relished the chance to have different kinds of conversations about the future of science and society with their students, freed from the constraints of the curriculum.

Another strongly future-oriented project was *HUMAN+: The Future of Our Species*, exploring the complex theme of human enhancement, from extreme longevity and performance-enhancing drugs to prosthetics, genetic enhancement, and cyborgs. First unveiled in Science Gallery in 2011, *HUMAN+* was then itself enhanced and reincarnated at CCCB in Barcelona, and later at ArtScience Museum Singapore and the Palazzo degli Esposizioni in Rome under the curatorial leadership of Cathrine Kramer. An ambitious project, it involved a wide range of artists, designers, geneticists, and roboticists in framing questions about our future as a species, including both existing works such as Stelarc's third ear, and new commissions such as Superflux's *Song of the Machine*, a meditation on the potential of optogenetics to allow a previously blind person to experience an augmented visual universe. It also included human-subject research experiments, one on the genetics of risk-taking and another on social robots.

What If We Could Seed Clouds Using Nanoparticles So It Would Snow Ice Cream?, Cat Kramer and Zoe Papadopoulou, The Cloud Project at *What If . . .* at Science Gallery in 2009. Source: © Science Gallery, Trinity College Dublin.

An endlessly ambiguous artwork we wanted to include in *HUMAN+* was *Natural History of an Enigma*, created by Brazilian bio-art pioneer Eduardo Kac. This was a "plantimal"—a petunia flower that had been genetically modified to include some of the artist's own DNA, allegedly expressed through the red veins in the petunia flower. The experience of trying to exhibit this work illustrates some of the challenges involved in bringing art and biology together in a public environment.

When we sought to import Kac's "plantimal" from Paris, we immediately ran into difficulties. At first we were not allowed to import it, but eventually the Irish Environmental Protection Agency (EPA) decided that we could import it, as they were not convinced by the evidence that it was a genetically modified organism. There was one condition though—we were not permitted to exhibit the plant as a GMO. This placed us in a strange

predicament. Our exhibition was entitled *HUMAN+* and we had gone to not insignificant expense to import an allegedly human-petunia hybrid from Paris to exhibit, which we were only permitted to display in the gallery as a petunia. We corresponded with the artist who expressed great irritation:

> There's a dimension of this issue that brushes into First Amendment rights. I'm an artist, not a scientist. The EPA can't tell me what I call my work. If I'd like to say it is from Mars, I can do it. I may even have grounds for suing the EPA for infringing on my free speech rights.[8]

After some back and forth, we convinced the artist to allow us to have the plant tested for the presence of human DNA by Trinity spinoff company IdentiGEN. The PCR tests were duly carried out, and, to our dismay, came back negative—the "plantimal" we were displaying in *HUMAN+* was, in fact, just a regular petunia. The artist responded that this must be due to the fact that second-generation seeds were used to grow the specimen, and eventually sent us some new seeds. IdentiGEN tested these, and indeed they did reveal the presence of human DNA. However, we were then informed by the EPA that we were not permitted to grow the seeds due to environmental regulations and they had to be destroyed, just as the exhibition closed.

We displayed the ongoing correspondence with the EPA alongside Kac's work in the gallery, to highlight the ambiguous status of the artwork, ultimately an impossible exhibit, but a wonderful prompt for discussion with visitors about our societal malaise about genetic modification.

Around this time, synthetic biology was emerging as a key topic of discussion, giving nanotechnology a run for its money in the hype stakes. The idea of designing new organisms by assembling bio-bricks was gaining currency through iGEM—the international Genetically Engineered Machines jamboree held annually at MIT. Synthetic biology was bringing designers

Eduardo Kac, *Plantimal IV*, lambda print on diasec (from the "Natural History of the Enigma" series), 16.5 × 16.5 in. (42 × 42 cm.), 2009. *Source:* Courtesy Henrique Faria Fine Art, New York.

into new conversations with biologists. Biohackers were also experimenting with synthetic biology outside of the regulations governing university and government labs. CRISPR-Cas9 had yet to explode on the world as a new approach to gene editing. In this context, working with a curatorial team including artist Daisy Ginsberg, designers Dunne and Raby, biohacker Cathal Garvey, and Imperial College London structural biologist Paul Freemont, and with support from Wellcome Trust, Science Gallery developed the exhibition *Grow Your Own: Life After Nature*. At the time of developing the exhibition, many aspects of synthetic biology were still being defined, so much so that it was almost impossible to have the curators agree about the fundamentals or even the language with which to describe synthetic biology.

Perhaps the most successful aspect of *Grow Your Own* was the creation of a Community BioLab in the gallery, in cooperation with Ellen Jorgensen of GenSpace in New York. Every week throughout the run of *Grow Your Own*, the Community BioLab hosted different groups in residency, doing experiments in public and with the public. Groups like Hackteria, ArtScience Bangalore and La Paillaisse from Paris showed visitors how to make inks from soil bacteria. One of the most popular projects involved a residency of smell provocateur and artist Sissel Tolaas and UCLA biologist Christina Agapakis.

In their project *Selfmade*, they created cheese, using bacteria from prominent figures. One was made using bacteria from *Omnivore's Dilemma* author Michael Pollan's navel. Another, a blue cheese, was created with bacteria scraped from curator Hans Ulrich Obrist's forehead. A third cheese was made using artist Olafur Eliasson's tears (apparently it is very tricky to extract bacteria from tears). During their residency in the Community BioLab, visitors to the gallery could experiment in making their own human cheese. The rule, dictated by health and safety regulations, was that one could only taste one's own cheese—and merely smell other people's cheeses. The residency opened with a wine and human cheese evening, with the sign advertising the event reassuring visitors "don't worry, the wine is normal." Tolaas's and Agapakis's project was an immediate media sensation, being featured on CBS, PBS, *National Geographic*, *Dezeen*, *The Guardian*, and even stimulating a discussion of the human microbiome and its gastronomic potential on the normally scientifically immune Fox News.

A controversial speculative project featured in *Grow Your Own* was Japanese designer Ai Hasegawa's *I Wanna Deliver a Dolphin*, which combined two human desires, the desire to give birth and the desire to protect the environment, by conceiving a scenario where women could choose, instead of increasing the human population,

to give birth to an endangered species, such as the Maui dolphin, enhancing interspecies empathy.

A Maui dolphin is roughly the same size as a human baby and is regarded as highly intelligent. For a woman to gestate a dolphin, Hasegawa proposed biologically modifying a placenta to prevent the passage of antibodies from mother to baby that attack nonhuman cells. "The placenta originates from the baby's side, which in this case is a dolphin, and not from the human side," said Hasegawa. "This avoids the ethical and legal difficulties associated with reproductive research involving human eggs."[9]

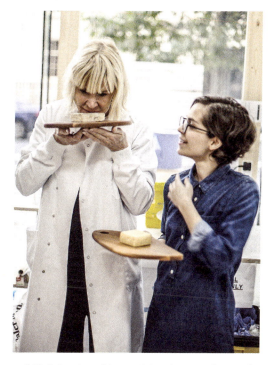

Sissel Tolaas and Christina Agapakis examining cheese made using bacteria harvested from humans as part of *Selfmade*, shown in *Grow Your Own* at Science Gallery. *Source:* © Science Gallery, Trinity College Dublin.

In Heather Dewey-Hagborg's project *Stranger Visions*, portrait sculptures were created from discarded DNA found around Dublin on discarded cigarette butts. "The intention is to confront the viewer with the possibility that someone might be able to examine their DNA and inspect their identity from detritus they didn't even know they left behind."[10]

Science Gallery exhibitions such as *What If . . .* , *HUMAN+*, and *Grow Your Own* confronted people as consumers with possible future products and services. Through creative collaborations between science, art, and design, they asked, Which future would you choose? Bringing in transdisciplinary curatorial teams to help us investigate current concerns, and to help bring in the voices of different communities, was critical to such projects—examples of the Idea Collider in action.

Spawning the Global Science Gallery Network

From the beginning, Science Gallery was conceived as a new connective tissue between the university and the city. For centuries, Trinity College had been perceived as a protected oasis of learning in Dublin's city center, surrounded by high railings and impenetrable to the uninitiated, except for the busloads of tourists visiting the Book of Kells in Trinity's spectacular Long Room library.

As well as being an Idea Collider, Science Gallery described itself as aiming to be a "porous membrane" for the university, drawing the researchers and students out, and drawing the public and creative community in, to spark off new kinds of boundary-defying conversations and creative collaborations.

Even in the early, challenging days of Science Gallery, it was believed by the founding team that if this experiment were to work in Dublin, there was no reason this approach to transdisciplinary public engagement might not work in other locations with a

Ai Hasegawa, *I Wanna Deliver a Dolphin*, 2011, shown in *Grow Your Own* at Science Gallery. *Source:* © Science Gallery, Trinity College Dublin.

university in an urban center, in the age of the "engaged university," when universities around the world were being required to develop a vision for public impact, and also to stimulate transdisciplinary research.[11]

Science Gallery aimed to establish a set of tools and approaches to nurture "creative collisions" between university-based researchers, artists, designers, and the public that could be used and ultimately expanded on by other universities. These tools included open calls, transdisciplinary curatorial teams, the Leonardo Group, the mediator program, Lab in the Gallery, and other mechanisms tested in Dublin as elements of the Idea Collider. After a couple of prolonged, but instructive, false starts with interest in creating a Science Gallery in Singapore and Moscow, King's College London approached the gallery. They had wanted to set up a new public engagement space on their Guy's Hospital biomedical campus at London Bridge for some time. An initial, more conventional science outreach proposal to Wellcome Trust had been rejected. Claire Matterson of Wellcome suggested they should talk to Science Gallery, and the vision for Science Gallery London was born. Simultaneously, we received a €1 million gift from Google.org (Google had been a key founding supporter of the Dublin Science Gallery) to launch the Global Science Gallery Network, allowing us to set up a new nonprofit organization, Science Gallery International, with the goal of bringing Science Gallery experiences to a global audience.

King's College London was the first international member of the network, and we worked with King's to secure capital funding for their gallery, recently opened at a spectacular site at the foot of the Shard, with funders including Wellcome Trust and the Guy's and St. Thomas's Charity. The goal of the founding team, including neuroscientist Daniel Glaser and former Royal Opera House creative director Deborah Bull, was to build on the Dublin experience in crafting a vision for the gallery with its own distinct identity based on the gallery's location in a hub of health and healthcare.[12]

Science Gallery projects are also now in advanced development at the University of Melbourne (under the leadership of Rose

Hiscock), in India's science and technology hub Bangalore with the Indian Institute of Science, National Centre for Biological Sciences, and the Srishti School of Art, Design and Technology (directed by Jahnavi Phalkey), and in contemporary art and architecture hub Venice with Ca' Foscari University, with the vision that each gallery will inspire creative collisions between local and global scientists, artists, designers, and technologists, and share content and ideas through the network, now developing further under the leadership of Andrea Bandelli with galleries also in planning in Detroit, Atlanta, and Rotterdam.

Rather than a "one-size-fits-all" model, which could never work in such diverse local contexts, the vision is that each gallery will build on the approaches developed in Dublin, adding its own distinct local flavor, and pooling new approaches and formats with the other members. While Dublin was reasonably successful in attracting and engaging young adults, other galleries in the network are creating structures to encourage greater local ownership of the galleries, greater youth creative input, and greater engagement of economically and socially disadvantaged communities, which generally only came into the Dublin gallery through collaborations with community organizations—many of these lessons could ultimately be of great benefit to the future evolution of the Dublin gallery.

If it is not a project to "inform the public about science" or to "promote science," as some of its original promoters might have hoped, then what is Science Gallery ultimately about? Perhaps most of all, as a "collider for ideas," as outlined in chapter 1, Science Gallery is creating a fertile environment for creating social capital—sparking off new social connections and relationships for the public, for the students, for the scientists, for the artists, for the entrepreneurs, for the designers, around a shared interest in our future.[13]

WINDOWS
Ten Shifts: Redefining Cultural Institutions

What kinds of cultural institutions will thrive in the twenty-first century? How is the nature of our cultural and educational institutions shifting, including the future manifestations of science museums and science centers? Ten shifts can provide insight into the changing nature of these institutions. These shifts are not unique to the museum world, and are also characteristic of the broader educational and cultural spheres. They may be considered as a set of axes or dimensions for cultural change. Perhaps surprisingly, given the transformative role of digital technology in changing the way we learn, share, and collaborate, none of these trends turns out to explicitly about "technology," though adapting to them may well require embracing or developing different technological tools.

Table 1
Ten key shifts in cultural institutions

Twentieth century	Twenty-first century
large	small
slow	fast
stable	agile
interactive	participatory
dative (to/for)	ablative (by/with/from)
enclosed	porous
content provider	creative platform
visit experience	meeting place
stand-alone	networked
subject-specific	cross-disciplinary

The list above, inspired in part by the work of educational theorist Stephen Heppell, is not exhaustive. There is also nothing magical about the turning of the new millennium. Instead, many of these shifts are, I suggest, a consequence of the radical

reorganization of our knowledge and culture brought about by the internet, mobile technologies, and other seismic changes in the ways we learn, share, and socialize. I would like to take these large-scale cultural shifts in turn, and consider briefly how they might apply to the concept of a science museum.

W1 Shift 1: large → small

Clayton Christiansen's classic book *The Innovator's Dilemma: When New Technologies Cause Great Firms to Fail* (Harvard, 1997) makes the point that it is extremely difficult for large organizations to remain innovative. As organizations grow, the very factors that originally made them successful have a tendency to stifle their ability to innovate and adapt. It is far easier for small organizations to innovate and take creative risks. I believe we are seeing a shift from enormous museums with vast collections and hundreds of staff to small, flexible, dynamic "cultural centers of science." We are seeing a greater emphasis on ephemeral activities—events, festivals, picnics—as discussed in chapter 2. We are seeing small labs popping up, sometimes in partnership with universities (for example, SymbioticA in the University of Western Australia, Art-Science Lab at UCLA, Le Laboratoire in Paris), and smaller, more adaptable spaces such as Science Gallery in Dublin discussed in the previous chapter. This is not to say that larger organizations cannot have a culture of innovation, however. According to Christiansen, large organizations can innovate and remain relevant only if they create a "skunkworks"—a small organization within the large organization which is allowed to "break all the rules," something that is common practice in large technology companies from Lockheed to Hewlett Packard. In the cultural space, many museums and other cultural institutions are attempting to create skunkworks spaces for more experimental projects, with the Ars Electronica FutureLab being one example.

W2 Shift 2: slow → fast

Science and technology are changing very quickly. Audiences are becoming used to "as-it-happens" information. Museums have a habit of developing exhibitions very slowly, sometimes over a number of years, and have difficulty in "rapid response" to current scientific culture. This has a tendency to create a gap between museums and the bleeding edge of research and technological innovation, and to prevent researchers from engaging significantly with museums and their publics, barring rather structured and sometimes forced interactions. Museums need to be able to develop new skill sets and mind-sets around working fast—more of a production mind-set, where a strong events program becomes as important as exhibitions, and where the very notion of "permanent exhibitions" may be open to question.

W3 Shift 3: stable → agile

If science museums have an aspiration to have a transformative role on visitors, in the past this role was often associated with generating new "scientists" or promoting general "scientific literacy" in the public. However, we are seeking to motivate, inspire, and engage a new kind of person now—flexible, creative, collaborative thinkers and makers who can move between different areas of knowledge, between art and science, between technology, design, and business. This poses a challenge to our educational and cultural institutions, requiring much greater agility and flexibility, and the ability to tap into current concerns and anticipate future trends. Our teams, rather than being made up of narrow domain specialists, need to be able to "turn on a dime" to generate programs and rapid-response events.

[handwritten annotation: EXPLAINER VIDEOS — TIK TOK & INSTAGRAM. IN RESPONSE, WE SHAPE THE NARRATIVE]

W4 Shift 4: interactive → participatory

[handwritten annotation: public research good example]

The notion of interactivity, so beloved of the science centers that spread around the world in the 1980s, has had its day. Interactivity is now banal. Rather than interacting with machines, people are interested in participatory experiences, where they can contribute to shaping the experience and where they are helping design and cocreate. Unlike interactivity, participation is essentially social, and requires a relinquishing of control on the part of the institution.

W5 Shift 5: dative → ablative

Belfast-born designer Sean McDougall, involved in designing the process for decommissioning weapons during the Northern Irish peace process, has coined the helpful term "ablative thinking." Dative cultural institutions are institutions that give things *to* an audience—expertly curated exhibitions, operas, films, plays. Ablative cultural institutions, on the other hand, allow projects to be done *by* or *with* the community or draw ideas *from* the public. Large, established cultural institutions, including science museums, frequently have a dative approach—expert curators develop content which is then pushed out to the public. A major shift for science museums involves moving to an ablative approach, requiring completely different mechanisms for content generation. Sometimes this has been described as a "museum 2.0" approach, but clearly it goes far beyond the online experience. In practice this is often delivered in a highly tokenistic way—an ablative veneer on a dative institution. However, the most dynamic, vital, and relevant cultural institutions of the twenty-first century are likely to be ablative to the very core. This requires a radical rethinking of staff roles, curatorial policies, and programming and engagement strategies. In the case of Science Gallery, it was at least as important to consider what we could get from our visitors as what we could impart to them. Science Gallery extracted blood, sweat, DNA, first memories, and many other deeply personal items from visitors. In *Blood Wars*, for example, conceived by artist Kathy High, blood was taken from visitors with the help of a professional phlebotomist installed in the gallery. White blood cells of different visitors were stained different colors and could then engage in gladiatorial combat under the microscope, to see who had the most powerful immune-defense system. Somewhat poignantly, Kathy High herself suffers from Crohn's disease, meaning that she always tended to win against other contenders at *Blood Wars*.

Artist Kathy High preparing *Blood Wars*, in which blood is drawn from different gallery visitors and then their white blood cells (stained either red or green) are put into gladiatorial combat. © Science Gallery, Trinity College Dublin.

W6 Shift 6: enclosed → porous

Whereas twentieth-century cultural institutions generally had rigid boundaries between "us" and "them," between "staff" and "public," between "inside" and "outside," these boundaries are now becoming more porous. Instead we are seeing concentric communities with differing levels of engagement with the museum, with the "committed core" acting as an extended team of the museum staff, given a voice and a platform by the institution, and providing their time, networks, and creative energies in return. The porous institution is not bounded by walls. Science museums that bring their activities into unexpected locales, from nightclubs to music festivals and fashion shows, will be successful in reaching new audiences who would not otherwise consider walking through the doors of a science museum. New strategies of engagement are required to create the extended creative community of the science museum. It is clear that inward-focused educational and cultural institutions cannot remain relevant.

W7 Shift 7: content-provider → creative platform

Following on Shift 5, there is a shift going on in the role of the museum as content provider to that of a creative platform for a core community. A place where scientists, artists, designers, entrepreneurs, schoolchildren, and other groups can express themselves creatively. From a focus on instructing young people in basic science in an accessible/engaging/entertaining way, there is more of a focus on inviting in people with different kinds of expertise to explore and create the future of science and technology together. Becoming a creative platform rather than a content provider raises many challenges for the traditional operating model of the science museum. Systems of content development involving tight policing of didactic messages for scientific accuracy need to be replaced by a relinquishing of some control. This requires science museums to be willing to take certain risks, to be more open to experimental activities, to shift focus to frontier areas of science and technology, and to act more as facilitators and catalysts for a creative community than as a paternalistic voice of authority.

W8 Shift 8: visit experience → meeting place

The idea of the museum as primarily a visit experience, a linear "ride," which may be superficially interactive but offers the visitor little opportunity for genuine contribution, is under challenge from other models for cultural and creative spaces. If museums are aiming to engage a core committed community serving as an "extended team" for the in-house staff, then the museum needs to become a place for that community to meet, to exchange ideas, to drop in, and to feel welcome. Exhibitions and events created by that extended community spark off critical discussions and further creative connections. To move from visit experience to meeting place requires a radical rethinking of the business model of the museum—in creating a core of regulars who come to the museum of their own free will, free entry is required, as well as an environment where people feel comfortable meeting and sharing ideas informally. Starbucks popularized the concept of the "third place," a place where you spend time that is "in-between" home and work. A key observation is that real physical meeting places remain extremely important to people in spite of new communications technologies. The richness of face-to-face interaction has not yet been replaced by technology; physical meeting places still matter. To remain relevant, museums need to recognize and extend their roles as places for meeting and exchange of ideas, going beyond a core community or "tribe" and inviting new people into the conversation.

W9 Shift 9: standalone → networked

In the twenty-first century it is impossible to think of a new museum project without giving serious consideration to a network strategy. There are several different models available for the networked museum or cultural institution. The extension of "franchised" collection-based museums like the Guggenheim Bilbao or Louvre Abu Dhabi are one high-profile case in point. In these cases, valuable collections and iconic buildings, combined with a long-established and prestigious museum brand, are at the heart of the value proposition to target locations. Can we imagine new models for the networked museum which could encompass some of the other cultural shifts described here? For example, what would an "ablative" museum network look like, functioning more as a distributed brain than as "prepacked content" that is touring or being duplicated in a network. Where the "franchising" of the Louvre and the Guggenheim were built on long-established brands, for the museums of the future a network strategy may even become primary, preceding the establishment of the flagship iconic space. Science Gallery, for example, is currently establishing a network of spaces in partnership with universities around the world—where each node in the network is expected to be creative, generating its own program, exhibitions, and events from the local creative community, and sharing them through the network. Rather than the "top-down" network characteristic of the Guggenheim and Louvre franchises, in a context where the mission is more about engagement than access to high-value collections, it is interesting to reflect on what a bottom-up network of cultural centers for science may look like, each one drawing on the strengths of its local creative and scientific community. Not a hub and spokes network but a "multi-hub" network, with virtuous feedback mechanisms between the different members so that valued innovations developed by one member may be shared with the others.

W10 Shift 10: subject-specific → cross-disciplinary

In recent years, as documented in chapter 3, there has been an explosion of multidisciplinary spaces engaging with science, especially art-science spaces. In a period of just six months, Wellcome Collection, Le Laboratoire in Paris, and Science Gallery in Dublin opened their doors, all with different approaches to the art-science interface. Since then a slew of new spaces have emerged around the world, ranging from the art-science lab in UCLA and Arts Catalyst in London to Santa Monica in Barcelona. Longer-established cross-disciplinary spaces include the Ars Electronica Festival in Linz and SymbioticA in Perth, Western Australia. Why this explosion of new cross-disciplinary cultural institutions? The idea of bringing the arts and sciences together is nothing new. Nonetheless this proliferation of new art-science spaces is a dramatic trend. I would suggest that the cause is a response to a crisis in the specialization of the traditional educational and cultural institutions precipitated by new technologies. Exhibitions and events that bring together people across disciplines to collaborate are increasingly common. The public also responds well to cross-disciplinary projects, as broad themes of concern and relevance can be explored from a number of disciplinary perspectives. Cross-disciplinary teams are essential for innovation, and we are finding that many of these new spaces, rather than simply presenting science or technological innovations to an audience, are actually serving as sites of research and innovation, emphasizing the need for transdisciplinarity. Artists, scientists, and designers are equal partners in these new spaces and projects.

5
The Biological Turn

The science centers that emerged across the globe in the 1980s and 1990s, inspired by Frank Oppenheimer's Exploratorium and festooned with hands-on interactive displays, were the offspring of the "century of physics," the twentieth century, which saw an extraordinary upheaval in physics, from the emergence of relativity and quantum mechanics in the early part of the century, to the Manhattan Project, and Frank's brother Robert Oppenheimer's famous evocation of the Bhagavad Gita, "Now I am become Death, the destroyer of worlds," following the Trinity nuclear test explosion.

As biotechnologist and entrepreneur Craig Venter has argued, however, the twenty-first century is increasingly the "biological century," where the key environmental and health challenges we face, and the most disruptive areas of scientific research with potential for significant social upheaval, from the so-called "CRISPR Babies" to xenotransplantation, are biological in nature, and where we are also witnessing a rapid fusion of biology and digital technologies, so that even life itself can be referred to by Venter as a "DNA software system."[1]

The combination of engineering and design with biology is epitomized by iGEM, the international Genetically Engineered Machines jamboree, held annually at MIT, where young student contestants from around the world create projects that contribute to a shared library of parts—biobricks that can be used like Lego bricks to design living organisms with new properties and behaviors to create indigo dye for blue jeans from soil bacteria or to make the E. coli bacteria commonly found in excrement smell like bananas.

If one had to choose a single object to emblematize the century of physics, it might be the rather alarming Gilbert U-238 Atomic Energy Lab, a physics kit containing radioactive materials designed to allow exciting and (supposedly) safe experiments to be done by amateur scientists at home.

Gilbert U-238 Atomic Energy Lab. *Source:* Photo by author.

The unfolding biological century, on the other hand, is encapsulated in the promise of portable kits such as the Bento Lab invented by Philip Boeing to allow DNA analysis to be performed anywhere, and an expanding number of kindred DIY-bio kits and devices.

Fields as diverse as architecture, fashion, healthcare, medical devices, environmental restoration, and food are now looking to biology for not merely inspiration, as in the earlier movement of biomimetic design, but also for new materials and living machines to offer solutions to global challenges, ranging from plastic pollution and the biodiversity crash to global pandemics and antibiotic-resistant bacteria.

Bento Lab, portable genomics lab combining centrifuge, PCR, and gel visualization, Philipp Boeing. *Source:* Bento Lab (www.bento.bio).

So how does the biological turn we are currently experiencing affect how we conceive of and design science museums and science centers?

Traditionally, the dominant role in the public presentation of biological themes in the museum context has been occupied by natural history museums. But how well adapted are natural history museums to exploring the new frontiers of life sciences in the twenty-first century?

Invented in their current form during the Industrial Revolution, natural history museums presented a striking contrast to the museums of science and industry emerging during the same time period. Most of the nineteenth-century natural history museums were defined primarily by a research agenda, with the enlightenment and entertainment of the public being at best a secondary goal, following the core missions of research, collecting, and classification.

Even the radical invention of dioramas in the early twentieth century, designed to position species in environmental context and highlight interrelationships in ecosystems, created a huge debate between those favoring a strict research agenda, for whom the visitors were more or less a distraction and competition for the limited resources of the museum, and those so-called "Museum Men" pushing towards experiential education in natural history museums, as beautifully described in the fascinating and meticulously researched study *Life on Display*, by Karen Rader and Victoria Cain.[2]

Kirk Johnson, director of the Smithsonian American Museum of Natural History, has recently described museums of natural history as "a nineteenth-century solution reinventing itself to address twenty-first century problems."[3]

Traditionally, natural history museums presented an image of the natural world where the human was conspicuously absent, present only outside of the exhibition as the observer. If humans were on display, they were indigenous others, treated as "part of nature" or early hominids. As John Berger put it,

> In the accompanying ideology, animals are always the observed. The fact that they can observe us has lost all significance. They are the objects of our ever-extending knowledge. What we know about them is an index of our power and thus an index of what separates us from them. The more we know, the further away they are.[4]

However, it is no longer possible to consider the living world without attention to the deeply entangled nature of the human and nonhuman worlds.

From the microbiome to the biodiversity crash, humans are inextricably intertwined with other living systems. In a way, the term "Anthropocene," with its rather abstract emphasis on the long-term geological footprint of our species, misses the key point.

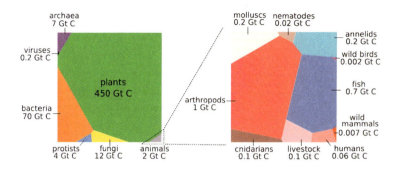

Biomass distribution on earth, showing that humans and livestock make up ninety-five percent of mammal and bird life on land. *Source:* Y. M. Bar-On, R. Phillips, and R. Milo, "The Biomass Distribution on Earth," *Proceedings of the National Academy of Sciences* 115, no. 25 (2018).

A 2018 study has demonstrated the profound influence of humans on the biosphere. This study aimed, for the first time, to measure the biomass distribution of Earth across all taxa. A startling conclusion was that 95 percent of all mammal and bird life on land consists of humans and livestock.[5]

The most common bird in the world is, by a long stretch, the chicken, with over 25 billion chickens alive on the planet right now. Livestock, especially cattle, are a key cause of greenhouse gas emissions (up to 30 percent of all greenhouse gases) and even the eating habits of pet dogs and cats cause approximately 64 million tons of CO_2 equivalent emissions per year.

Yet in spite of their remarkable proliferation and influence (one might even say, genetic success!), domestic species barely feature in most natural history museums. This is an issue which has been pointed out in particular by Richard Pell, who created the Center for PostNatural History in Pittsburgh as a place and artistic project to provoke discussion of human-influenced evolution.

Pell's tongue-in-cheek exhibits, celebrating, for example, the chicken as the successor to Tyrannosaurus Rex, appropriate the visual traditions of natural history museums to tell a very different story where human influence on evolution is the centerpiece, rather than a footnote. Pell's approach (which traces the "postnatural" back to the earliest domestication of species by humans) goes against the grain of a powerful visual tradition, permeating not only museums but also wildlife filmmaking, of "nature" as blissfully bereft of human influence, something that was certainly untrue during the Industrial Revolution of the nineteenth century, and is even less true in the twenty-first century.[6]

In relation to biodiversity, the stock-in-trade of natural history museums, we are experiencing a moment of radical transformation.

Richard Pell, *Domestication of the Dinosaur. Source:* Center for PostNatural History.

On the one hand, we are in the midst of what author Elizabeth Kolbert has termed the "Sixth Extinction," likening the current rapid pace of extinctions to the Cretaceous-Tertiary mass extinction 65 million years ago that wiped out most of the dinosaurs. Currently, amphibians are being wiped out at 25,000 times the background extinction rate, and this is largely due to human influence (including pathogens being distributed globally through air travel, as well as the more familiar issue of destruction of habitat through agriculture and urbanization). The current biodiversity crash has led biologist E. O. Wilson to propose a rather radical solution: turning 50 percent of the Earth's land surface into a conservation area, the so-called Half-Earth Project. Wilson's proposal, which is mapped out in great detail on the project website, amounts to the creation of a giant nature park, where humans and their needs (including agriculture) are relegated to their own enclosure, and where humans and nature are once again separated by some kind of fence dividing the world in half.

On the other hand, human activity is not only causing extinctions and a reduction of biodiversity, but is also accelerating evolution and thereby generating new species. Countering the focus on extinctions, Chris Thomas has the more optimistic view that "we have created a global archipelago, a species generator, which will give rise to considerably more species on Earth than existed before humans started to spill out of Africa. Come back in a million years and we might be looking at several million new species whose existence can be attributed to humans." According to Thomas, rather than needing to carve out half the planet as a conservation park as E. O. Wilson would propose, we are already living in the park: "We can think of the world as a biological park, Anthropocene Park, with ourselves as both custodians and inmates."[7] In this vein, evolutionary biologist Menno Schilthuizen has recently argued that cities are profoundly important accelerators of evolution,

creating serendipitous collisions between different species that would not otherwise find each other if left to their own means, at a dizzying rate, allowing us to observe evolution and even speciation occurring within a lifetime.

In addition to the challenges around the biodiversity crash and human impact on evolution, we are confronting a dizzying array of biological and biotechnological innovations that urgently require public discussion, from cellular agriculture transforming the meat industry to the ethical discussions around CRISPR and designer babies. Natural history museums are poorly equipped to discuss such questions.

Designer Neri Oxman has suggested that we are now living in the Age of Entanglement, and our human relationship with the biosphere is clearly a powerful example. As Oxman puts it, "If Enlightenment was the salad, Entanglement is the soup. In the Age of Entanglement it becomes impossible to discern one ingredient from another."[8]

So how can museums hope to deal not with the Enlightenment "salad" of neatly separated disciplines and hierarchical taxonomical organization, like separate tomatoes, lettuce, and cucumber, but with the "soup" of the Age of Entanglement, when humans and other species are inextricably interwoven, and when designers and biologists, ecologists and biotechnologists need to find a common language to address global challenges?

It seems that a "modernization" of the charming but dated model of the natural history museum is not going to be sufficient to cope with the transformations we are currently experiencing in biological sciences. Indeed, there is much to be said of celebrating and conserving classic natural history museums (for example, the incredibly beautiful Bone Hall in the Gallery of Palaeontology in Paris or the "dead zoo" in Dublin) precisely because they confront us with a fascinating, historically embedded image of the natural

world, rather than attempting to modernize by, for example, sprinkling a few garish digital interactive displays amongst the specimens.

Rather than simply modifying these existing museums, and their vast dinosaur halls and biodiversity walls, we have an urgent need to invent new, more dynamic models for spaces to engage the public with life sciences.

Interesting experiments in this regard are taking place—for example, Micropia in Amsterdam was opened in 2014, announcing itself as a "zoo for microorganisms," alongside Amsterdam's main (macro-) zoo Artis. Visitors experience living microorganisms and learn about their importance.

The Tech Museum of Innovation in San Jose, once the archetypal Silicon Valley technology museum, has opened up to biology and biotechnology, including highly ambitious interactive exhibits on synthetic biology, and a BioDesign Studio, where designers in residence such as Philip Ross help visitors to create building materials out of mushroom mycelia, or to create ink from bacteria.

The Exploratorium, in its beautiful new Pier 15 home in San Francisco, offers visitors the chance to capture plankton from the bay, and analyze it on microscopes in the museum, and offers a host of biological exhibits ranging from decomposing rats and shivering *Mimosa pudica* to a large biolab allowing for ambitious experiments by staff and scientists-in-residence. In its early days, Exploratorium had generated some controversy through its hands-on grasshopper experiments allowing one to twitch the leg of a grasshopper using an electric current, and even more radically, to show the activity of grasshopper neurons during vision through an implanted wire electrode recording from the ventral nerve cord of the grasshopper.

The California Academy of Sciences, in its spectacular renovation designed by Renzo Piano, places significant emphasis

on its large rainforest, and many museums have brought visitors close to living systems by including large-scale living collections, blurring the lines between natural history museums, zoos, and aquaria.

The California Academy of Sciences, along with the Museum für Naturkunde in Berlin, have also been leaders in establishing the museum as a key instigator of citizen science projects, as discussed above.

Simultaneously, museums such as the Deutsches Hygiene Museum in Dresden, Wellcome Collection in London, and the Medical Museion in Copenhagen are becoming important places for interdisciplinary debate and research in relation to emerging medical technologies and bioethics, and bringing the sensibility of cultural historians to bear on medical debates.

Design museums, from the Cooper Hewitt to the Cube Museum in the Netherlands and the Triennale in Milan, are also refocusing interest on the biological world. In 2019, even Centre Pompidou in Paris held an exhibition, *La Fabrique du Vivant*, exploring artificial life.

It is in this context, and this moment of reinvention of the natural history museum for the biological century, that Biotopia is being developed as a new museum and forum for life sciences and environment in Munich.

Unlike traditional natural history museums, Biotopia will focus on understanding, and ideally reconfiguring, the relationships between humans and the other life forms with whom we share the planet. It plans to explore these relationships through the lens of behavior—focusing on the behaviors, processes, and activities that link us with other species, from eating and sleeping to sex and communication.[9]

Biotopia aims to go beyond the starting point of curiosity, to encourage visitors to experience a shift in perspectives, creating

interspecies empathy, and ultimately to inspire action—personal agency. While many museums have succeeded in engaging the curiosity of visitors, only a few are successful in stimulating shifts in perspective, and very few indeed are able to stimulate agency, in the sense of helping to stimulate follow-on action by visitors beyond the duration of the museum visit. For a museum interested in agency, the exit experience of the visitor becomes even more important than the entrance experience—how do we help give the visitor some helpful scaffolding for what they might do next, whether it might be through involvement in an environmental project or a citizen science activity? How do we offer them an opportunity to take their interest to the next level?

Sometimes this does not require complex technology, but merely a shift in mindset. For example, Nina Simon and her team created an exhibition called *Lost Childhoods,* exploring the often difficult experiences of children in foster homes, at the Museum of Arts and Humanities in Santa Cruz. As you left the exhibition, you could tear off a phone number depending on which action you wished to pursue. If you were keen to bake a birthday cake for a foster home resident, there was a phone number of someone who would take the cake delivery. Such a simple, low-tech approach, although it may have appeared to place quite a high bar for visitor engagement, yielded a very strong response rate. These are the kinds of approaches we are trying to inject into the design of Biotopia.

In a sense, museums of natural history were often built around a core of amateur collections, so at their root they have a strongly cooperative and community-based approach, which has unfortunately tended to be lost with the professionalization of the sector.

Biotopia will be a flexible platform, including a range of open/public labs—an "eat lab" to explore and experiment with future food, a bio-art and design studio to create designs and artworks

inspired by or using biological materials, a neuro-lab where visitors can participate in neuroscience experiments, and a biolab for working with living materials, from tissue culture to synthetic biology.

Biotopia's programming will be animated by residencies of ecologists, scientists, designers, and chefs, and it will aim to reach an audience going beyond the school groups and families that traditionally visit natural history museums to include young adult and adult audiences.

Initiating and prototyping its activities through an annual festival, and through the Biotopia Lab opening in 2020, Biotopia is an experiment in the future of museums which is still in the making, and part of a larger worldwide family of organizations seeking to create a more dynamic and flexible platform to engage with the urgent challenges and exciting opportunities facing us in the biological century.

ns
6

Piercing the Filter Bubble: Science Museums and Social Capital

Back in 2011, internet activist Eli Pariser coined the prescient term "filter bubble" to describe the phenomenon that, as a result of algorithms biasing our social media feeds, we have an increasing tendency to live in self-reinforcing echo chambers, where we are rarely confronted with world views that conflict with our own.

In recent times we have seen the filter bubble phenomenon exploited to devastating effect by shadowy firms such as Cambridge Analytica, playing out in the 2016 US elections, in the Brexit referendum in the UK, and in populist elections across Europe, through precise targeting of voters.

The filter bubble phenomenon in social media has provided a nutritious growth medium for the rise and reinforcement of anti-science views and the spread of "fake news" on topics ranging from climate change to vaccinations.

Prior to the dominance of social media over opinion-formation, as documented by Chris Mooney in his book *The Republican War on Science*, the oil lobby, for example, had to work hard and invest significant communications funds to copy from the Big Tobacco playbook (funding doctors to discredit the link between cigarettes and lung cancer) to create contrarian positions and confuse the public about the links between fossil fuels and climate change. Following the advent of the filter bubble, it is more and more difficult for many people to evaluate which sources of information to trust. This breakdown of trust is an issue not only in the United States, but also in other countries where populist leaders have risen to power, for example, Poland, Turkey, Italy, Hungary, and Brazil.

When social fragmentation occurs, as already documented in the United States by Robert Putnam in his classic book *Bowling Alone*, and civic institutions break down, different groups can effectively inhabit their own reality and become increasingly insulated from conflicting views.

In relation to science, this becomes especially concerning when, for example, we see measles epidemics striking very affluent

areas due to anti-vaxxers distrusting scientists, or where we have widespread apathy about climate change due to world leaders expressing skepticism about its very existence.

In recent times we have witnessed some attempts to counter this widespread distrust of science. One example is the March for Science, first held in April 2017 in Washington, DC, and in other cities around the world.

One of the troubling features of the March for Science, a reaction especially to the Trump administration's denialist position in relation to climate change and generally anti-science stance, was that it tended through its messaging to foster a caricature of science as a set of certainties and facts. While, for example, in the case of anthropogenic climate change, it may be very tempting to say that the science is simply settled and a matter of fact, representing the whole of science as a body of certainties, rather than an ongoing process of discovery, is a risky strategy, which can expose scientists to attacks when, inevitably, new discoveries challenge and overturn previous "established facts."

Some have suggested—even though scientists know it is a misrepresentation of the messy nature of science—that science should be presented in public as a set of indisputable facts, as a strategy to increase public trust in science. This is the position taken by, for example, the Australian public ethics professor Clive Hamilton, who calls this approach "strategic essentialism" and proposes it as a line of defense for science in the age of "alternative facts."

However, reasserting the certainty of science in the face of these attacks is a problematic strategy to regain scientific authority, likely doomed to fail. Trust in an institution is not the same as faith, which deals in absolute certainties. French sociologist Bruno Latour, a key figure in the so-called "science wars" of the 1990s, criticizes this as an approach to restoring trust to science. Latour,

who was astonished to see his own arguments mobilized by oil lobbyists to muddy the waters about climate change science, now sees his role as rebuilding trust in science. Whereas in the 1980s and 1990s, science was the establishment, we are living in radically different times now, when science is increasingly becoming more like the underdog, fighting for survival as key institutions are dismantled. We are not (yet) living in the dystopian world of *Fahrenheit 451*, where books were banned and burned and could only survive when their contents were memorized by members of the resistance, but we can no longer simply take the stability and survival of our scientific institutions for granted. But propagating a deception, a "noble lie" about the nature of science, is not the solution.

As Rachel Botsman has recently argued, deception (rather than secrecy) is the enemy of trust. According to Botsman, trust essentially boils down to just four key ingredients. These are: competency (your expertise and knowledge of the subject matter); reliability (that you are consistent in your behavior and views, that you "show up on time"); empathy (that we feel you genuinely care about us); and integrity (that there is alignment between your words and deeds, and that my intentions are aligned with yours).[1] Science has traditionally scored highly in relation to competency and reliability. However, science has arguably not always demonstrated empathy and integrity in dealing with public controversies—if science wishes to regain trust, establishing empathy and integrity should be top priorities.

How does this affect the mission of science museums and science centers? I believe that in these times of populism and anti-science, science museums and science centers could have a hugely important role to play in helping to rebuild public trust in science, but that they must do this, as Latour suggests, not by proclaiming science as absolute certainty, but by providing a glimpse into science

in the making, into mechanisms for evaluating evidence, and by demonstrating empathy, through developing better listening skills, and integrity, by considering how to align the interests of scientific institutions more visibly with those of the public.

Rather than being places for absolute certainty, historian and museum director Neil MacGregor has proclaimed that the museum should be a place for doubt, where you emerge with fewer certainties than you held when you went in. The German word *Zweifel*, meaning "doubt," will be emblazoned in giant neon letters on the side of the roof of the Humboldt Forum, where MacGregor was one of three directors, opening soon in Berlin.

Science museums have traditionally struggled with the Cartesian method of doubt, finding it difficult to reconcile their pedagogical goals of knowledge transmission with uncertainty and skepticism. One of the few museums that thrives on doubt is the Museum of Jurassic Technology created by David Wilson in Culver City, Los Angeles. Described beautifully by Lawrence Weschler in his book *Mr. Wilson's Cabinet of Wonder*, the Museum of Jurassic Technology has the strange effect of leaving visitors in a state of profound doubt about the veracity of everything they have just seen (including the material that is in fact historically accurate), precisely because it plays on the "objective" labeling and traditional forms of presentation of science and technology museums with tongue-in-cheek displays of improbable knowledge.

What would it be like, then, for science museums and science centers to embrace doubt and to foster disbelief in visitors, rather than promulgating facts as certainties? This is an uncomfortable but rewarding area for experimentation where collaborations with artists, who often thrive on ambiguity, can be especially fruitful.

However, in addition to stimulating doubt and critical thinking, there is an even more significant role for science museums and science centers that is often overlooked or sidelined,

but which offers perhaps the most important opportunity for such institutions to pierce the filter bubble.

In a famous essay, *The Forms of Capital*, sociologist Pierre Bourdieu outlined the distinction between economic, cultural, and social capital. Economic capital generally consists of property (for example, land) convertible into cash. Cultural capital includes knowledge and skills and, for example, university qualifications and degrees that serve as a proxy for these. Social capital, for Bourdieu, was defined as "the aggregate of the actual or potential resources which are linked to possession of a durable network of more or less institutionalized relationships of mutual acquaintance and recognition—or in other words to membership in a group."[2]

Where economic capital can be succinctly defined as "what you have," and cultural capital can be defined as "what you know," social capital can be summarized in simple terms as "who you know," and how you can mobilize your social networks.

Recently, Louise Archer and others have proposed the expansion of Bourdieu's trio to include the concept of "science capital":

> The concept of science capital can be imagined like a "holdall," or bag, containing all the science-related knowledge, attitudes, experiences and resources that you acquire through life. It includes what science you know, how you think about science (your attitudes and dispositions), who you know (e.g. if your parents are very interested in science) and what sort of everyday engagement you have with science.[3]

While the concept "science capital" has a certain appeal and catchiness, one issue I have with it is that it bundles up precisely what Bourdieu and others separated, something that is especially problematic in relation to the past and future role of museums. Museums, including science museums, have been designed in the past as archetypal instruments for the transmission of cultural

[Handwritten at top: INSPIRING ACTION VS CONVEYING KNOWLEDGE]

capital. Understanding collections, whether of objects of art or science, has itself been a hallmark of connoisseurship, and a badge of social distinction since at least the sixteenth century.

In the specific case of science museums as they emerged in the nineteenth century, this means that they have been designed to convey knowledge and (occasionally) skills in relation to science, technology, and industrialization. But if we wish to reimagine science museums, it is deeply problematic to consider them primarily as expensive machines for transmitting cultural capital to a broad audience, for a number of reasons.

First, it is almost redundant to observe that the means of transmission of cultural capital have been radically transformed in the past decades. Much of the world's cultural capital is now ubiquitously available to anybody in possession of a smartphone. When young women in the slums of Delhi possess smartphones, access to cultural capital has become trivial. Mobilizing interest then becomes a much more significant challenge than providing access to information.[4]

Second, the stories that science museums tell, and the objects they display, often do not connect meaningfully with significant sections of the population, as has been documented in the case of London by Emily Dawson in her recent book *Equity, Exclusion and Everyday Science Learning*, where "exclusion" has been built into the structures of institutions themselves. While there are small ways that this can be improved (for example, providing multilingual signage), these often do not speak to the root problem, which is simply that the content itself does not speak to the interests and concerns of minoritized groups, or even conveys a colonialist and exclusionary narrative.[5]

Third, we have known for a long time, from the work of Bruno Latour, Steven Shapin, Simon Schaffer, Sharon Traweek, and countless other scholars in the field of Science and Technology

[Handwritten at bottom: In a world where anyone, anywhere, can access scientific information, world science, data, etc.]

Studies, that science should not be considered as a body of facts and certainties, but as a profoundly socially embedded process. Science exists in highly structured social networks, demonstrated visibly by processes such as peer review, tenure committees, and funding decisions. So therefore the very idea of a science museum as a place to transmit factual knowledge—cultural capital—whether through signage or a hands-on interactive exhibit demonstrating the Bernoulli principle, seems to misconstrue the nature of science.

So I would like to argue the simple point that as we imagine future science museums, science centers, and other kindred organizations, we need to make a fundamental shift from the time-honored practice of focusing on the transmission of cultural capital, to a focus on the transmission of social capital. Science museums, in my view, need to be reimagined not as places to acquire science literacy or science facts, but as places to become *plugged in* to a living, embodied, human network, including scientists but also the many other actors involved in the scientific enterprise.

Robert Putnam makes a helpful distinction between two varieties of social capital: "Bonding social capital brings together people who are like one another in important respects (ethnicity, age, gender, social class, and so on), whereas bridging social capital refers to social networks that bring together people who are unlike one another."

Putnam notes that the external effects of bridging networks are likely to produce positive social outcomes, whereas bonding networks are at greater risk of producing negative externalities (with extreme examples of bonding networks being, for example, the Ku Klux Klan or ISIS).[6]

Importantly, bridging works in both directions. It is not just a question of ensuring that the broader public gains access to the networks of science, but that the practitioners of science gain access to the diverse perspectives, insights, and experiences of other areas

of society. It is as vital to bring greater diversity into science as to bring "outsiders" into contact with scientific networks.

So how can science museums and science centers hope to reinvent themselves as machines for transmitting Putnam's "bridging social capital"? Or, more precisely, how can they convert economic capital into bridging social capital, as someone ultimately has to pay for all this, whether the state, industry sponsors, philanthropic foundations and individuals, or the visitors themselves?

I would like to illustrate this with a personal story. When I was seventeen years old, I was travelling through Germany with my clarinet. I was hoping to pursue a career in classical music, and playing with various orchestras and groups, but also busking in the streets to support myself, and gradually wondering (as I played *Eine Kleine Nachtmusik* for the thousandth time for a few jangling coins) if a path in classical music was really the right future for me.

I hitchhiked down to Munich, and while exploring the city, visited the famous and vast Deutsches Museum. I was quite impressed by the working models of hydraulic machines on display, the reconstructed coal mine, the Faraday cage, and remarkable steam engines, and somewhat daunted by the sheer vastness of the museum. But nobody spoke to me during the entire visit.

When I returned to Ireland a few months later, through a connection with my school in Dublin, I had a chance to meet a physics lecturer at Oxford University. We only spoke for about 20 minutes, but in this short time I heard strange ideas about Schrödinger's Cat, relativity, and time-travel that I had never before encountered at school. Fascinated to know more, and with encouragement from school and family, I applied to study physics at Oxford, and was extremely fortunate to benefit from free college education in Oxford, before the Blair government ended this opportunity in the UK.

This is clearly a story of social capital and tremendous privilege—if I had not had the connection through attending a middle-class school in Ireland and had not had a supportive family, I would never have met the physics professor and would never have dreamt of pursuing a degree in physics or applying to Oxford.

But it is also a story of what didn't happen—I was clearly at a point in my adolescent life where I was highly receptive and open to ideas regarding my future, and if the right person had connected with me in the museum, my epiphany to "plug myself in" to the world of science could arguably just as easily have happened there, but it didn't.

So how could the kind of epiphany I had—a fascinating conversation with someone who was passionate about science—be opened up to people who do not benefit from the social networks I was able to access?

In the earliest European museums, social capital was also extremely important, but in precisely the opposite (exclusionary) way. One could not gain access to early cabinets of curiosity such as Athanasius Kircher's museum in Rome without possessing a letter of introduction from a person of distinction, as shown proudly on the frontispiece of the catalogue of the museum published in 1651, where two visitors are shown presenting Kircher with such a letter, a visible act of conversion of social to cultural capital.

Part of the founding DNA of Science Gallery in Dublin was the goal of supporting new social connections. Even as the gallery opened, we proclaimed it as a place where a visit would be as much about who you might meet as what you might see. While certain formats of events allowed for "table dating" with prominent scientists, or workshops with extraordinary artists and engineers, the frontline of this mission were undoubtedly the people we called the mediators, discussed above. These were generally science and engineering students at different levels from Trinity College

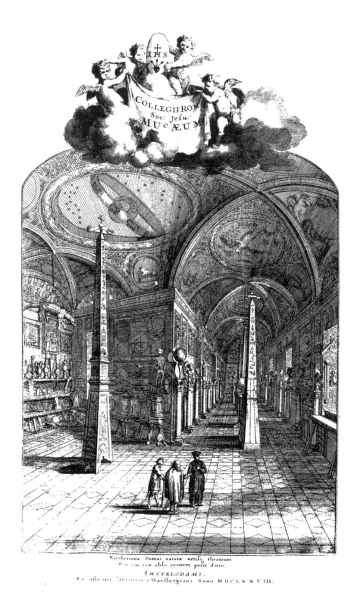

Athanasius Kircher receiving visitors to his museum in Rome, from "The Musaeum Kircherianum," in *Giorgio de Sepibus, Romani Collegii Musaeum Celeberrimum* (Amsterdam: Ex Officina Janssonio-Waesbergiana, 1678). *Source:* Courtesy of the Stanford Libraries' Department of Special Collections.

Dublin, as well as some humanities students. We of course didn't think at the time of the mediators as serving the role of transmitting bridging social capital, by connecting the visitors to the social world of science, but in an important sense this was what they were doing, by engaging the public in conversation (rather than transmitting information), using the exhibits and experiments in the gallery as triggers to conversations on wide-ranging topics and trying to discover connections with the personal interests of the visitors, and advising visitors on other events and programs they could participate in and opportunities to connect with interesting scientists, artists, and designers. Such conversations were not about "promoting science" or trying to encourage visitors to become scientists, but often involved open critical discussions about ethical issues raised by the work on display. It should be added that the concept of mediators is not completely unique to Science Gallery Many science centers and museums have "explainers" or "docents," but the role varies from more "performative" and "informative" (demonstrators or tour guides) to the more conversational role intended for Science Gallery mediators (in practice, charismatic divas will always emerge, and it can sometimes be difficult to rein in the lecturing instinct and remind mediators that they should be listening fifty percent of the time).

The role of the museum in this scenario is something akin to what Maria Montessori described as the "prepared environment," a prepared space allowing for open exploration and social learning, and providing scaffolding for conversation and social connection.

One thing we discovered about the mediators in Science Gallery was that they were extremely popular with the visitors, so much so that people tended to rate the conversation that they had with a mediator more highly than any individual exhibit in visitor surveys, leading the gallery team sometimes to speculate about whether we actually needed the exhibits at all, or could instead just have wallpaper on display.

Another thing we discovered, in addition to the clear benefit to the visitors, was that the mediators themselves, and some of the leading scientists, were transformed through the process of engaging with Science Gallery. Science students often had minimal experience in communicating with different publics prior to engaging with Science Gallery, but the training they received and the experience of having to discuss topics with widely different audiences, where one day you might have a homeless group being taken through the gallery and another day you might have a Nobel laureate, enhanced their communication skills significantly, leading to "mediator superstars" emerging with their own radio shows, creative agencies, public engagement projects, or TV shows. Geneticist Aoife McLysaght had done almost no science communication activities before engaging with Science Gallery on a number of exhibitions, but in 2018 was guest lecturer of the Royal Institution Christmas Lectures, the holy grail of science communication, attributing her development of her ability to connect with a wide variety of audiences to her experiences with Science Gallery. So Science Gallery appeared to be contributing in a small way to the creation of a new kind of scientist—more communicative, more open, and more able to engage with diverse publics and make connections with people and ideas outside their specialism.

In one instance, I was approached after an event at Science Gallery by a young woman, Lara Dungan, who had begun pursuing science but had given up. She asked me if there were any part-time jobs at the gallery. I mentioned that we had mediator positions, but they were normally for current students. She was insistent, and we agreed to give her a trial run as a mediator during the *Infectious* exhibition. She then made the decision to apply for a PhD in biochemistry with one of the scientists involved in creating the exhibition, and has since won multiple awards for her research and is a regular presenter about science topics on national radio.

There are of course significant challenges with this model of bridging social capital, both practical and structural. On the practical side, such approaches (facilitating human connections and conversation within museums and science centers) are extremely resource intensive. Also, it does not often provide durable connections, unless the mediators can help the visitors to identify what to do next, or how to engage more deeply (whether through a workshop or other activity). On the structural side, there is a significant danger of what Bourdieu calls social reproduction, rather than true bridging social capital. If large communities feel excluded and do not even visit the museum space, or if they do visit but do not feel reflected in the staffing or connected to the content, then bridging will fail with these communities, and instead we have a risk of simply reinforcing existing social divisions by providing valuable experiences to and for an elite.

How can we mitigate against this? In the case of Science Gallery, drawing mediators from the Trinity College student population clearly meant a bias towards students from an elite background, those who had already made the decision (and had the resources) to go to a prestigious university. However, working in partnership with the Trinity Access Programme was a mechanism to ensure that students from diverse ethnic and socioeconomic (and also, importantly, linguistic) backgrounds were included amongst the mediators. By placing a stronger emphasis on in-person conversation rather than written signage, we found that having mediators with multiple language competencies was a helpful way to connect with audiences who might otherwise have found the gallery inaccessible.

As Science Gallery has expanded into a global network, social justice and equity have been considered with greater attention. For example, Science Gallery London created a Young Leaders program involving youth from the local community of

Lambeth and Southwark directly in decision-making around content of programs. Many science centers have also worked (often in cooperation with community-based organizations) to involve students from diverse ethnic and social backgrounds as "explainers."

However, even changing the face of the museum staff, so it reflects more accurately the diversity of the community in which it is embedded, does not help terribly much if key groups don't set foot in the museum in the first place. As Dawson has shown, there are large tranches of the population for whom a museum or science center visit is simply "not for them," including perceived cost (economic and opportunity costs), lack of time, lack of relevance of the content of the museum to their interests, and the physical location of the museum. Even the very common attempt to promote inclusion through school visits and schemes specifically targeting disadvantaged schools can be counterproductive for future visits if people feel that they were "dragged to the museum" by their teachers.

Some of these problems may appear intractable. But there is hope. By reconceiving the science museum as a machine for transmitting social capital, rather than cultural capital, many items of the "standard operating procedure" can fall by the wayside.

Why do you need (as in Dawson's study) to bring people to large, cathedral-like buildings in South Kensington to see historic exhibits if the ultimate goal is to expand their social networks and connect them to the dynamic human web of science, in connection with all other areas of society? Sure, this may work for some people who can connect with the content and narratives provided at such locations, and we should not dismiss the valuable and excellent work that these museums are doing in their magnificent buildings, but for others the museum is freed up to act in very different and unexpected ways, freeing itself of the baggage of the very label "museum."

A simple experiment that Science Gallery undertook in Dublin was to take over a vacant shop front in the city center and turn it into what we called Makeshop. This appeared on the surface to be a retail environment, but allowed people to wander in and participate in all sorts of walk-in, hands-on workshops, from building DrawBots to making neon-light sculptures. Even though Makeshop was located only a few hundred meters away from Science Gallery, the fact that it was a storefront meant that it attracted a very different audience, including people who would hesitate before walking through the door of a glass-fronted gallery with a large reception desk. By appropriating the familiar visual and architectural language of a retail space, it reached a different audience, an audience perhaps more at ease in a mall than in a museum.

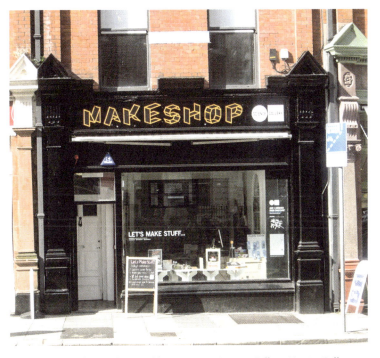

The shop front of Makeshop, Dublin. *Source:* © Science Gallery, Trinity College Dublin.

Groups such as Guerilla Science that have been bringing playful science experiences to music festivals and other unexpected locations also represent a different way to connect with audiences who might otherwise avoid science museums like the plague. Creating community maker spaces, coder dojos, labs, and hacker spaces, as discussed previously, can give an even greater degree of local ownership over such activities.[7]

To summarize, if we wish to have any hope of piercing the filter bubble, addressing the current rise of populism and anti-science views, and offering marginalized groups opportunities to engage with and contribute to science, I propose that we need to reframe the purpose of science museums and science centers as connectors and brokers, as providers of bridging social capital, rather than transmitters of cultural capital. This will require a radical shift in the way such institutions are designed, a shift away from thinking "inside the walls" of iconic starchitect-designed buildings, towards a more networked, connected, social, rhizome-like vision of the museum.

7
From Incubators to Idea Colliders

As we approach a global population reaching over nine billion people by 2050, society faces a number of pressing challenges. We are currently living in a world where the wealthiest one thousand people could, if they wished, support a comfortable lifestyle for the one billion poorest people, and where an area the size of a football pitch is deforested every second, to make way for agriculture and expanding cities. From wealth inequality to climate change, from plastic pollution to the global biodiversity crash, from artificial intelligence threatening jobs to populism hijacking social media to undermine democratic structures, from the emergence of antibiotic-resistant bacteria to the increased risk of global pandemics through air travel, we face a myriad of complex challenges.

These complex challenges are closely interlinked, and their solutions require new collaborations between scientists, industry, policymakers, engineers, designers, and practitioners from many other fields.

On the other hand, we are experiencing a process whereby the tools of science are becoming cheaper, smaller, and more widely available.

Consider that it cost $2.7 billion and about 15 years to sequence the first human genome, but now anyone can get their entire genome sequenced and analyzed within a few weeks for under $1,000. Cheap access to equipment and tools for PCR analysis and genome editing—CRISPR kits and so on—present exciting opportunities for a new generation of amateur scientists and biohackers but also serious issues in terms of regulation. The FBI and UN weapons inspectors regularly hold workshops at events like the iGEM contest at MIT to warn against the dangers of misuse of such tools for bioterror or accidental contamination. The democratization of science presents great opportunities but also new risks.

We are living in a time when it has never been more urgent to connect the public into the living network of science, but also, equally or more importantly, to connect research scientists with a diverse network of practitioners and publics outside the field to effect social and political change. Science needs the public perhaps even more than the public needs science. This is an area where science has in past decades been failing abysmally, due to structures that reward hyper-specialization, leading to some of the challenges we are now facing in relation to the public distrust of science. We need to transform science itself, to make its institutions more porous, more connected to external fields, more diverse, more open to the public, more open to input from other disciplines. Science needs to be able to articulate its relevance to widely different audiences, to embrace greater diversity, and to bring in external perspectives.

What could solve this problem? We clearly cannot rely on algorithms to solve these issues, as they have contributed significantly to the fragmentation of the present time. And, as discussed above, embodied social encounters appear to remain extremely important to our species. Schools have a role to play in developing attitudes toward science, but cannot alone create the "bridging social capital" to reach into the world of research discussed in the previous chapter.

So I have argued here that we have an urgent need for civic spaces to function as dynamic, bidirectional bridges between science and society—as colliders of ideas and people—and this must be a central role of science museums of the present and future. Science museums no longer need to be conceived as vast cathedral-like spaces, monuments to past triumphs of knowledge and ingenuity. Rather than as stand-alone monuments to knowledge, science museums and science centers need to be reconceived as vital connective tissue—supporting new and serendipitous social connections between researchers and the public, enriching

and transforming both in the process. Where museums have traditionally been considered as places to take objects out of circulation—off the market, so to speak—we need to reimagine the circulatory museum, the museum with a pulse.

As discussed previously, we urgently need to make such spaces inviting not only to children, but also to adults, if we are to have a hope of science playing its role in a functioning democracy, especially in view of our changing demographics.

On the other hand, I am not proposing that we simply need a new version, or an "upgrade," of the interactive science centers that spread around the world in the 1980s and 1990s—a new "one-size-fits-all" model, which would rapidly stultify.

The field of science engagement itself is still a relatively young field, and what we really need is an atmosphere of experimentation with new approaches, but always at the junctions, at the intersections, at the edges. There is a growing tendency in our field to emphasize best practice, and to focus almost excessively on measurement of impact. In both science and science engagement, excessive focus on measurement of impact can have a tendency to curtail experimentation, when what is needed for the current crisis is arguably bravery and radically different approaches rather than "business as usual." Who measured the impact of the Bauhaus in Weimar, or Black Mountain College, or Billy Klüver's 9 Evenings, or Niels Bohr's Copenhagen? What "impact assessment" or "best practice" drove the creation of the iPhone or the discovery of CRISPR-Cas9 as a gene-editing tool?

We will need enlightened funding organizations and philanthropists to support such experimentation. The Wellcome Trust has played a pioneering and visionary role in this regard in the UK, but we need more brave foundations, philanthropists, governments, and corporations worldwide to fund not just research, but the essential connective tissue between research

and the public. We need funding to take a more "venture cultural" approach and focus on supporting individual cultural entrepreneurs—junction-makers—in building these bridges and in encouraging experimentation. Research funding provided to universities and research institutions should require a strong vision for public engagement, going beyond the box-ticking "outreach" activities typically adopted. And such experiments need not always be costly—many of the new life forms discussed in this book do not require large, expensive new buildings for their realization, but can piggyback on existing spaces and facilities.

In the last decades, universities and research institutions have placed significant focus on establishing incubators to support spin-offs of university research. I would like to argue that we now need to place at least as much emphasis on creating Idea Colliders—places to connect emerging research with the public, drawing the insights and concerns of the public into research, and through this process, transforming the role and relevance of the university itself. Science Gallery was conceived with the vision of being such an Idea Collider, designed to be at the edge of the university campus, and fostering new social connections and participation of visitors. As it expands as a global network, from Bangalore to Detroit, it will inevitably draw on a different cultural context in each location. But what is perhaps most interesting is the potential for such a "porous membrane" to transform the host university or research institution, and to change science from within.

Humans have always been the great colliders. Intentionally and unintentionally, whether through combining concepts from diverse fields, spreading viruses through air travel or through bringing together different biological species in our cities to spark off new evolutionary pathways.

I began this book with Yo-Yo Ma's description of the "edge effect," in which he remarks that it is where two ecosystems meet

that one finds the greatest variety of new life forms. In times of ecological collapse and global pandemics, it has never been more urgent to focus on reimagining our existing science museums and creating new edge spaces, to bring science-in-the-making into contact with policy, to bring research into contact with the public—the future of our planet depends on it.

Let the new life forms emerge!

[Handwritten annotations:]

Metropolis ✱

THE EDGE

Ex of Edge of the city between the natural world and the human world to develop a new way to appreciate nature and live in harmony with it (Gaming) Save Planet

- Nature — Instill appreciation
- Public research (Stanford) Public Health
- Expeditions (wanderings) — collective VR —
- Future Tech — ham tech w/ T.E.C. impact life

Notes

Chapter 1

1. Yo Yo Ma, "Art for Life's Sake: A Roadmap from One Citizen Musician" (2013 Nancy Hanks Lecture, Washington, DC, April 8, 2013), https://iml.esm.rochester.edu/polyphonic-archive/wp-content/uploads/sites/13/2013/04/Art_for_Lifes_Sake_Hanks_2013-Yo-Yo-Ma.pdf.

2. Constance Holden, "Spreading the Flu," *Science* 324, no. 5930 (May 22, 2009): 995.

3. Luke O'Neill and Cliona O'Farrelly, "The Immune System as an Invisible, Silent, Grand Fugue," *Nature Immunology* 10 (2009): 1043–1045.

4. Philippe Vanhems et al., "Estimating Potential Infection Transmission Routes in Hospital Wards Using Wearable Proximity Sensors," *PLoS ONE* 8, no. 9 (September 2013): 1–9.

5. Including discussion with James Bradburne, then director of Palazzo Strozzi in Florence.

6. See https://surewash.com/about.

7. See David Edwards, *The Lab: Creativity and Culture* (Cambridge, MA: Harvard University Press, 2010).

8. See, for example, Nina Simon, OF/BY/FOR ALL, https://www.ofbyforall.org; her books *The Art of Relevance* (Museum 2.0, 2016) and *The Participatory Museum* (Museum 2.0, 2010); and Museum Hack, https://museumhack.com.

9. See Abigail Hess, "The Science and Design behind Apple's Innovation-obsessed New Workspace," in *CNBC Make It,* September 13, 2017, https://www.cnbc.com/2017/09/13/the-science-and-design-behind-apples-innovation-obsessed-new-workspace.html; and Amy Frearson, "Google's New HQ Will Be 'More like a Workshop than a Corporate Office' says Bjarke Ingels," *Dezeen*, March 5, 2015, https://www.dezeen.com/2015/03/05/bjarke-ingels-interview-movie-google-california-hq-thomas-heatherwick-workshop.

10. Quoted in Panofsky, "Galileo as a Critic of the Arts: Aesthetic Attitude and Scientific Thought," *Isis* 47, no. 1 (March 1956): 3–15.

11. On the origins of museums, see Karsten Schubert, *The Curator's Egg: The Evolution of the Museum Concept from the French Revolution to the Present Day* (London: One-Off Press, 2000); Oliver Impey and Arthur McGregor, eds., *The Origins of Museums: The Cabinet of Curiosities in Sixteenth- and Seventeenth-Century Europe* (Oxford: Ashmolean, 1985); and for naturalia, Paula Findlen, *Possessing Nature: Museums, Collecting and Scientific Culture in Early Modern Italy* (Berkeley: University of California Press, 1994).

12. See Iwan Rhys Morus, "Seeing and Believing Science," *Isis* 97, no. 1 (March 2006): 101–110, and Simon Schaffer, "Natural Philosophy and Public Spectacle in the Eighteenth Century," *History of Science* xxi (1983): 1–43.

13. On museums and soft power, see Gail Lord and Ngaire Blankenberg, *Cities, Museums and Soft Power* (Washington, DC: AAM Press, 2015).

14. K. C. Cole, *Something Incredibly Wonderful Happens: Frank Oppenheimer and the World He Made Up* (Boston: Houghton Mifflin Harcourt, 2009), 281.

15. Quoted in Claire Pillsbury, "Cybernetic Serendipity," in *The Art of Curiosity* (San Francisco: Weldon Owen, 2019), 138–139.

16. See Cole, *Something Incredibly Wonderful Happens*.

17. See V. Lipardi, "The Evolution and Worldwide Expansion of Science Centres," in *Science Centres and Science Events*, ed. Anne-Marie Bruyas and Michaela Riccio (Milan: Springer, 2013), 49–61.

18. See David Kaiser, "The Postwar Suburbanization of American Physics," *American Quarterly* 56 (December 2004): 851–888.

19. See Jorge Wagensberg, "The 'Total' Museum: A Tool for Social Change," *História, Ciências, Saúde—Manguinhos*, v. 12 supplement (2005), 309–321, and also Jorge Wagensberg and Terradas Architects, *Cosmocaixa: The Total Museum through Conversations between Architects and Museologists* (Barcelona: Sacyr, 2006).

20. See Sir Neil Cossons, "Industrial Museums in the New Millennium" (the 2000 European Museum Forum Lecture, Fondazione Luigi Micheletti), http://www.fondazionemicheletti.eu/contents/documentazione/archivio/Altronovecento/Arc.Altronovecento.04.03.pdf.

21. For the concept of ritualized play, see Ralph Borland, "The PlayPump," in *The Gameful World,* ed. Steffen P. Walz and Sebastian Deterding (Cambridge,

MA: MIT Press, 2015), 323–338. For theories of play, see also the classic book by Johan Huizinga, *Homo Ludens: A Study of the Play Element in Culture* (London: Routledge and Kegan Paul, 1949).

Chapter 2

1. See Nina Simon, *The Art of Relevance* (Museum 2.0, 2016).

2. For the zeppelin-airplane discussion see Freeman Dyson, *Imagined Worlds* (Cambridge, MA.: Harvard University Press, 1998), chapter 1.

3. See John and Ben Gribbin, "Forum: All the Fun of the Fair—the First Edinburgh International Science Festival," *New Scientist*, May 6, 1989, https://www.newscientist.com/article/mg12216636-400-forum-all-the-fun-of-the-fair-the-first-edinburgh-science-festival.

4. See Walter Isaacson, *The Innovators: How a Group of Hackers, Geniuses, and Geeks Created the Digital Revolution* (London: Simon & Schuster, 2014), 340–353.

5. As quoted in Boonsri Dickinson, "This Is Where Jack Dorsey's Vision for a New Payment System Came to Life," *Business Insider*, February 21, 2012.

6. *Incendie à la Casemate de Grenoble,* « *sans doute un acte volontaire* », France 3, November 21, 2017, https://france3-regions.francetvinfo.fr/auvergne-rhone-alpes/isere/grenoble/incendie-casemate-grenoble-doute-acte-volontaire-1369659.html.

7. See, e.g., Michio Kaku, *Physics of the Impossible: A Scientific Exploration into the World of Phasers, Force Fields, Teleportation, and Time Travel* (New York: Random House, 2009).

8. Hana Schank, "Science Fairs Aren't So Fair: These K–12 events are hardly more than a competition among over-involved parents," *The Atlantic*, March 12, 2015, https://www.theatlantic.com/education/archive/2015/03/why-science-fairs-arent-so-fair/387547.

9. From "Reproduction and DNA (Bobby Digital RZA Flow)," on the album *Science Genius, The Final BATTLES* (2013), https://genius.com/Double-r-bars-reproduction-and-dna-bobby-digital-rza-flow-lyrics.

10. See *The Evolving Culture of Science Engagement: An Exploratory Initiative of MIT & Culture Kettle, Report of Findings, September 2013 Workshop* (Cambridge, MA: MIT, 2014), http://www.cultureofscienceengagement.net/s/Evolving-Culture-of-Science-Engagement-Phase-1-Report.pdf.

11. See J. K. Banfield et al., "Radio Galaxy Zoo: discovery of a poor cluster through a giant wide-angle tail radio galaxy," *Monthly Notices of the Royal Astronomical Society* 460, no. 3 (August 11, 2016): 2376–2384.

12. See P. S. Blackawton et al., "Blackawton Bees," *Biology Letters* 7, no. 2 (April 23, 2011): 168–172.

13. Alan Irwin, *Citizen Science: A Study of People, Expertise and Sustainable Development* (London: Routledge, 1995).

Chapter 3

1. Neri Oxman, "The Age of Entanglement," *Journal of Design Science*, no. 1 (January 13, 2016), https://jods.mitpress.mit.edu/pub/ageofentanglement.

2. Salvador Dalí, "Anti-Matter Manifesto" in *The Collected Writings of Salvador Dalí*, ed., trans. Haim Finkelstein (Cambridge: Cambridge University Press, 1998), 366–367.

3. See Arthur I. Miller, *Colliding Worlds: How Cutting-Edge Science is Redefining Contemporary Art* (London: W. W. Norton, 2014).

4. Marshall McLuhan, *Understanding Media* (New York: McGraw Hill, 1964), 71.

5. See, for example, Stephen Wilson, *Art + Science Now: How Scientific Research and Technological Innovation are Becoming Key to 21st-Century Aesthetics* (London: Thames and Hudson, 2010), and William Myers, *Bio Art: Altered Realities* (New York: Thames & Hudson, 2015).

6. See, e.g., Michio Kaku, *Physics of the Impossible: A Scientific Exploration into the World of Phasers, Force Fields, Teleportation, and Time Travel* (New York: Random House, 2009).

7. Bruce Sterling, "Preface," in *Next Nature: Nature Changes Along with Us*, ed. Koert van Mensvoort and Hendrik-Jane Grievink (Barcelona: Actar, 2012), 14–17.

8. On speculative design, see especially Anthony Dunne and Fiona Raby, *Speculative Everything: Design, Fiction, and Social Dreaming* (Cambridge, MA: MIT Press, 2013).

9. Steven Shapin, "Why the Public Ought to Understand Science-in-the-Making," in *Public Understanding of Science* 1 (1992): 27–30.

10. Quote from visitors brochure, reproduced in *Laboratorium*, ed. Hans Ulrich Obrist and Barbara Vanderlinden (Antwerp: DuMont, 2001), 17–23.

11. Bruno Latour, "From Realpolitik to Dingpolitik, or How to Make Things Public," in *Making Things Public: Atmospheres of Democracy*, exhibition catalogue, ed. Bruno Latour and Peter Weibel (Cambridge, MA: MIT Press/ZKM/Center for Art and Media in Karlsruhe, 2005), 4–31.

12. See Sharon Macdonald and Paul Basu, eds., *Exhibition Experiments* (Malden, MA: Blackwell Publishers, 2007), especially the essay by Peter Weibel and Bruno Latour, "Experimenting with Representation: *Iconoclash* and *Making Things Public*," 94–108, available online at https://onlinelibrary.wiley.com/doi/10.1002/9780470696118.ch4.

13. See Nicola Triscott, ed., *A Brief History of Arts Catalyst* (London: Arts Catalyst, 2014), https://www.artscatalyst.org/sites/default/files/project_attachments/20years-booklet.pdf.

14. See Sian Ede, *Strange and Charmed: Science and the Contemporary Arts* (London: Calouste Gulbenkian Foundation, 2000).

15. See Ken Arnold, "A Very Public Affair: Art Meets Science," *Interdisciplinary Science Reviews* 42, no. 4 (2017): 331–344.

16. See Paul Glinkowski and Anne Bamford, *Insight and Exchange: An Evaluation of the Wellcome Trust's Sciart Programme* (London: Wellcome Trust, 2009).

17. Arnold, "A Very Public Affair."

18. Quoted in Miller, *Colliding Worlds*, 166.

19. See Ariane Koek, "In/visible: The Inside Story of the Making of Arts at CERN," *Interdisciplinary Science Reviews* 42, no. 4 (2017): 1–14.

20. See Karsten Schubert, *The Curator's Egg: The Evolution of the Museum Concept from the French Revolution to the Present Day* (London: One-Off Press, 2000), 45, quoted in Arnold, *A Very Public Affair*.

21. See Paola Antonelli, "Design and the Elastic Mind" (TED Talk, Los Angeles, December 2007), https://www.ted.com/talks/paola_antonelli_previews_design_and_the_elastic_mind/transcript?language=en.

22. Jonathan Jones, "Should Art Respond to Science? On This Evidence, the Answer is Simple: No Way," *The Guardian*, April 23, 2015, https://www.theguardian.com/artanddesign/jonathanjonesblog/2015/apr/23/art-respond-science-cern-ryoji-ikeda-supersymmetry. See also Philip Ball,

"Only Great Work Can Really Justify Sci-Art Collaborations," *New Scientist*, December 31, 2017, https://www.newscientist.com/article/2157402-only-great-work-can-really-justify-sci-art-collaborations.

23. See David Mathews, "Simon Singh Criticizes Wasteful Spending in Science Outreach," *Times Higher Education*, October 13, 2015, https://www.timeshighereducation.com/news/simon-singh-criticises-wasteful-spending-in-science-outreach.

Chapter 4

1. Stephen Maguire, "Pill Poppers Target Art Gallery: They Keep Taking the Tablets. Junkies Pinch Exhibition Items to Feed their Habit," in *The Sunday Mirror*, April 20, 2008.

2. See Industrial Development (Science Foundation Ireland) Act 2003, http://www.irishstatutebook.ie/eli/2003/act/30/enacted/en/html.

3. See Howard Lovy, "When Nanopants Attack," *Wired*, October 6, 2005, https://www.wired.com/2005/06/when-nanopants-attack, and Leigh Phillips, "Nanotechnology: Armed Resistance," *Nature* 488 (2012): 576–579.

4. See Jeffrey C. Cooper et al., "Dorsomedial Prefrontal Cortex Mediates Rapid Evaluations Predicting the Outcome of Romantic Interactions," *Journal of Neuroscience* 32, no. 45 (2012): 15647–15656.

5. See M. J. Gorman, "Trinity Says Let's Talk," *Nature* 451 (January 31, 2008): 522, https://www.nature.com/articles/451522a.

6. See John Schwartz, "Museum Kills Live Exhibit," *New York Times*, May 13, 2008, https://www.nytimes.com/2008/05/13/science/13coat.html.

7. See Kathrine Enros and Andrea Bandelli, "Beyond Self-Confidence: A Participatory Evaluation of Personal Change in Science Gallery's Mediators," *JCOM* 17, no. 3 (2018), https://doi.org/10.22323/2.17030801.

8. Eduardo Kac, email to the author, April 28, 2011.

9. Quoted in Dan Howarth, "I Wanna Give Birth to a Dolphin," *Dezeen*, November 18, 2013, https://www.dezeen.com/2013/11/18/i-wanna-deliver-a-dolphin-synthetic-biology-concept-humans-giving-birth-to-food-by-ai-hasegawa.

10. Heather Dewey-Hagborg, "Stranger Visions," in *Grow Your Own . . . Life after Nature*, ed. Alexandra Daisy Ginsberg, Anthony Dunne, Paul Freemont, Cathal Garvey, and Michael John Gorman (Dublin: Science Gallery Dublin, 2013), 44.

11. See, e.g., John Goddard, *Reinventing the Civic University* (London: National Endowment for Science, Technology and the Arts, September 2009), https://media.nesta.org.uk/documents/reinventing_the_civic_university.pdf.

12. See Anthony King, "Global Science Gallery Launches," *Nature News Blogs*, July 13, 2012, http://blogs.nature.com/news/2012/07/global-science-gallery-network-launches.html.

13. On the early development and curatorial approach taken by Science Gallery, see also Ian Brunswick, "The Story before the Story So Far," https://ianbrunswick.wordpress.com/2017/06/02/229, and Andrea Bandelli and Ian Brunswick, "Answering the Unasked Questions," in *Art in Science Museums: Towards a Post-Disciplinary Approach*, ed. C. Rossi-Linnemann and G. de Martini (Milton Park, UK: Routledge, 2019), 154–163.

Chapter 5

1. See Craig Venter, "The Century of Biology," New Perspectives Quarterly 21, no. 4 (September 2004): 73–77.

2. See Karen A. Rader and Victoria E. M. Cain, *Life on Display: Revolutionizing U.S. Museums of Science and Natural History in the Twentieth Century* (Chicago: University of Chicago Press, 2014).

3. Quoted in *The Future of Natural History Museums*, ed. Eric Dorfman (Milton Park, Abingdon, Oxon, New York: Routledge, 2018).

4. John Berger, *About Looking* (London: Bloomsbury, 1980), 16.

5. Y. M. Bar-On, R. Phillips, and R. Milo, "The Biomass Distribution on Earth," in *Proceedings of the National Academy of Sciences* 115, no. 25 (2018): 6506–6511.

6. See, e.g., Gregg Mitman, *Reel Nature: America's Romance with Wildlife on Film* (Seattle: University of Washington Press, 2009).

7. Chris D. Tomas, *Inheritors of the Earth: How Nature Is Thriving in an Age of Extinction* (New York: Public Affairs, 2017), 179, 203.

8. Neri Oxman, "The Age of Entanglement," *Journal of Design Science,* no. 1 (January 13, 2016), https://jods.mitpress.mit.edu/pub/ageofentanglement.

9. See Michael J. Gorman et al., *BIOTOPIA: A Vision for a New Museum for Bavaria* (Munich: Biotopia Naturkundemuseum Bayern, 2017).

Chapter 6

1. Rachel Botsman, *Who Can You Trust? How Technology Brought Us Together and Why It Could Drive Us Apart* (New York: Public Affairs, 2017).

2. Pierre Bourdieu, "The Forms of Capital," in *Handbook of Theory and Research for the Sociology of Education*, ed. John G. Richardson (Westport, CT: Greenwood, 1986), 241–258.

3. Quoted from the video "A Science Capital Approach to Building Engagement," https://www.ucl.ac.uk/ioe/departments-and-centres/departments/education-practice-and-society/science-capital-research. On the concept of science capital, see also Louise Archer et al., "'Science Capital': A Conceptual, Methodological, and Empirical Argument for Extending Bourdieusian Notions of Capital beyond the Arts," *Journal of Research in Science Teaching* 52, no. 7 (2015): 922–948.

4. See Darrell Bricker and John Ibbitson, *Empty Planet: The Shock of Global Population Decline* (York: Crown Publishers, 2019).

5. Emily Dawson, *Equity, Exclusion and Everyday Science Learning: The Experiences of Minoritised Groups* (Abingdon: Routledge, 2019), and also the zine edition available at https://equityandeverydayscience.files.wordpress.com/2019/05/3e-zine-2019.pdf.

6. Robert D. Putnam, introduction to *Democracies in Flux: The Evolution of Social Capital in Contemporary Society*, ed. Robert D. Putnam (Oxford: Oxford University Press, 2002), 11.

7. See Mark Rosin et al., "Guerilla Science: Mixing Science with Art, Music and Play in Unusual Settings," *Leonardo* (May 2019): 1–11.